沾水筆、彩色墨水技法

INTRODUCTION TO

DRAWING WITH

PEN AND COLOR INK

目錄

CONTENTS

Translation by Gavin Frew
Layout by AGE.KK
Photograqh by Yasuo Imai

前言
Foreword

　　利用沾水筆及黑墨水的點描及線描是最具代表性的
技法，可以廣泛應用在筆壓、運筆、筆觸的各種表現
上。在此筆者希望各位能嘗試與彩色墨水（亦稱液狀透
明水彩）並用，拓展表現範圍。爲了使讀者將本書內容
應用於繪畫及插畫上，書中也介紹了從單色沾水筆畫到
鮮麗的彩色繪圖所需的技法。

ForewordThe basic techniques in monochrome pen and
ink drawing comprise of lines and dots but interest can
be created in the expression through variation of the
pressure and vigor of the strokes. Again, the use of
color inks, which are sometimes referred to as liquid
transparent watercolors, enlarge the scope of this field
enormously. This book covers all the techniques
needed to express everything from monochrome pen
and ink drawings to the vivid world of color and
allows you to create both serious pictures and comical
illustrations.

第一章
沾水筆與黑墨水的用法

Chapter 1
Using Pen and Black Ink

沾水筆的種類
Types of Pens

筆尖

沾水筆畫中線條、點的濃度
與所用墨水的濃淡是相同的。鋼
製筆尖富有彈性、故能改變筆壓
的強弱，表現出不同的線條，此
乃其一大特性。除了形狀互異之
外，不同筆尖所畫出的線條，也
各有微妙的差異。目前只要準備
圓筆、G筆及沾水筆，就够了。

Pen Nibs

The density of the lines and dots
in a pen and ink drawing is
dependent on the ink used. The
main characteristic of steel nibs is
that they have a certain amount
of flexibility which may be used
to create variation in the pressure
of the lines drawn. There are
numerous types available and the
shape of the tip produces subtle
changes in the lines. In the
beginning it will be adequate if
you have a round, a spoon and a
G-nib.

各式各樣的筆尖 Various Nibs

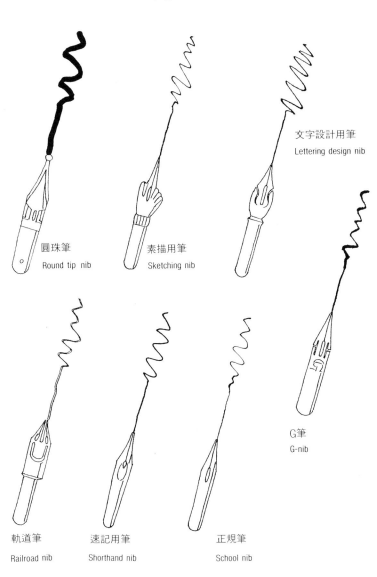

圓珠筆
Round tip nib

素描用筆
Sketching nib

文字設計用筆
Lettering design nib

軌道筆
Railroad nib

速記用筆
Shorthand nib

正規筆
School nib

G筆
G-nib

沾水筆
Spoon nib

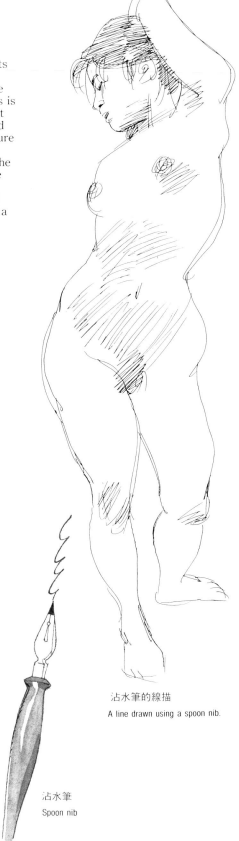

沾水筆的線描
A line drawn using a spoon nib.

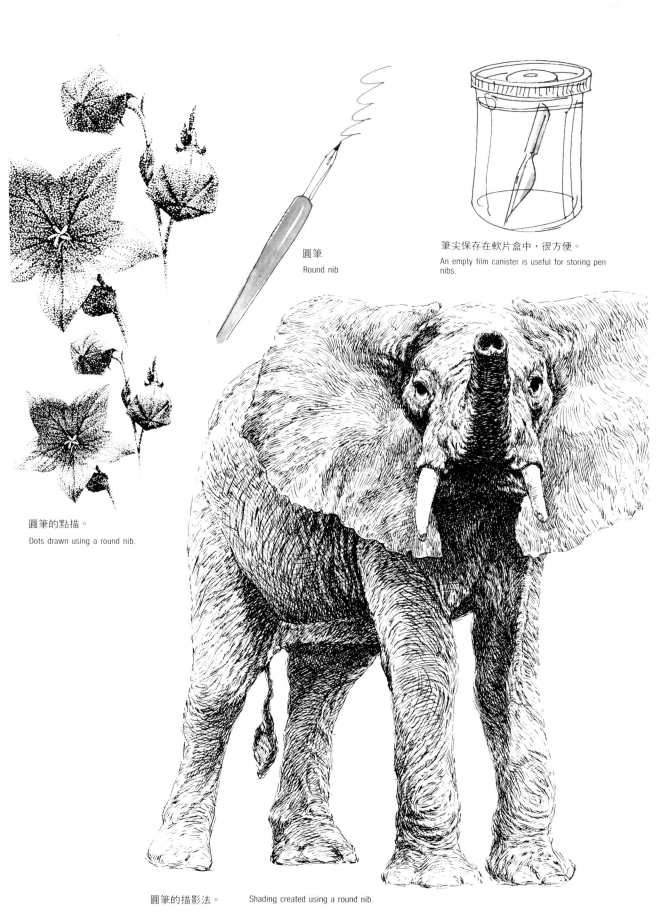

圓筆
Round nib

筆尖保存在軟片盒中，很方便。
An empty film canister is useful for storing pen nibs.

圓筆的點描。
Dots drawn using a round nib.

圓筆的描影法。　Shading created using a round nib.

沾水筆的種類

各種畫筆
Various Pens

製圖用筆就像鋼珠筆般，內有墨水。筆尖以0.1mm為
單位，不同大小的筆尖所畫出的線條粗細亦不同。原
子筆雖然不如製圖筆精細，但它能畫出一定粗細的線
條，非常方便。此外，還有各種不同粗細筆蕊的麥克
筆能畫出各式各樣的線條。

Drafting pens have a self-contained ink supply like
a fountain pen. Sizes come in increments of 0.1m/
m. so they may be used to create lines of uniform
thickness. Ballpoint pens do not come in such
accurate sizing, but they are useful as they may
also be used to draw a line of consistent thickness.
Felt-tip marker pens are also available in a variety
of sizes.

原子筆：分水溶性及耐水性二種。

Ballpoint pens : These come in both water-soluble and
water-resistant types.

製圖筆：筆尖以0.1mm為單位。

Drafting pens : The tips come in increments of 0.1 m/m.

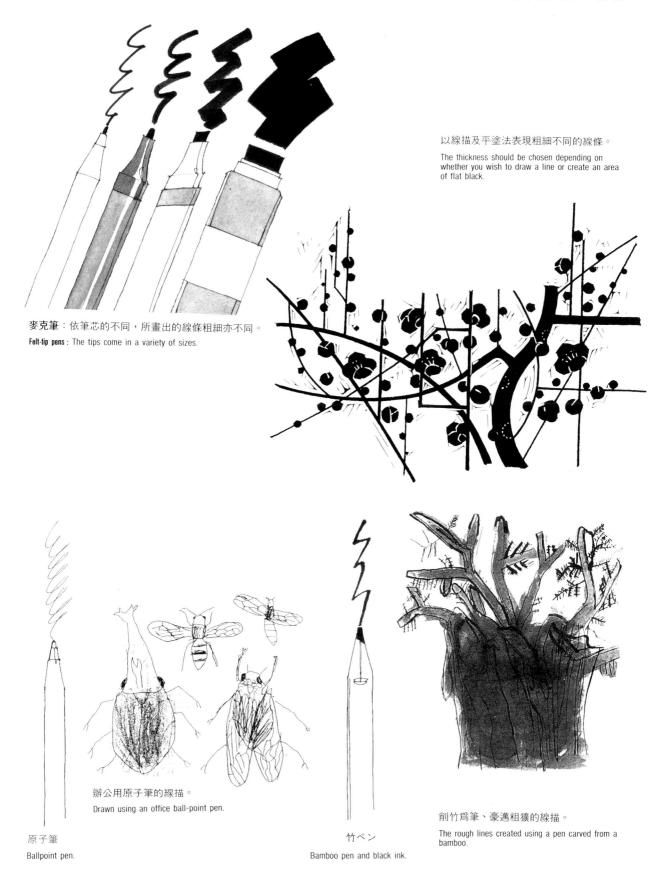

以線描及平塗法表現粗細不同的線條。

The thickness should be chosen depending on whether you wish to draw a line or create an area of flat black.

麥克筆：依筆芯的不同，所畫出的線條粗細亦不同。

Felt-tip pens : The tips come in a variety of sizes.

辦公用原子筆的線描。

Drawn using an office ball-point pen.

原子筆

Ballpoint pen.

竹ペン

Bamboo pen and black ink.

削竹爲筆、豪邁粗獷的線描。

The rough lines created using a pen carved from a bamboo.

黑墨水
Black Ink

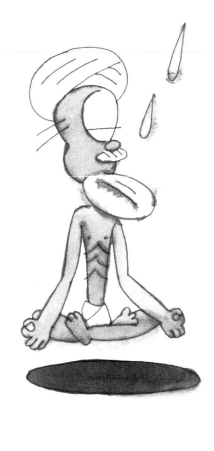

耐水性：乾後遇水不暈開。在原來的顏色上再上其他顏色也不會互相暈染。

Water-resistant Ink : Once it has dried, it will not run even if it is moistened. It will not run if color is applied over it.

水溶性：乾後遇水會暈開，不適合再上其他顏色。

Water-soluble Ink : It will run if water is applied to it after it has dried. It is not suitable for applying colors over.

黑墨水以水稀釋可製造出灰色調，控制自如。水溶性及耐水性墨水都能加水稀釋。

A grey tone may be achieved by diluting the ink with water to control the tone. Both water-soluble and water-resistant inks may be watered down.

墨水分屬耐水性及水溶性2種。線描、點描或平塗。時最好用耐水性墨水，若有需要時可用白色修正，較方便。如果要表現灰色調或渲染的效果，可用水溶性墨水。平時要常常搖一搖墨水瓶，可使墨水保存更長久。切記！

Inks come in water-soluble and water-resistant types. If black lines, dots and a flat coat of black are to be used, water-resistant ink is to be recommended as it will allow corrections to be made with white. If a grey tone or wet-in-wet is called for, water-soluble ink should be used. Ink will last longer if the bottle is shaken occasionally.

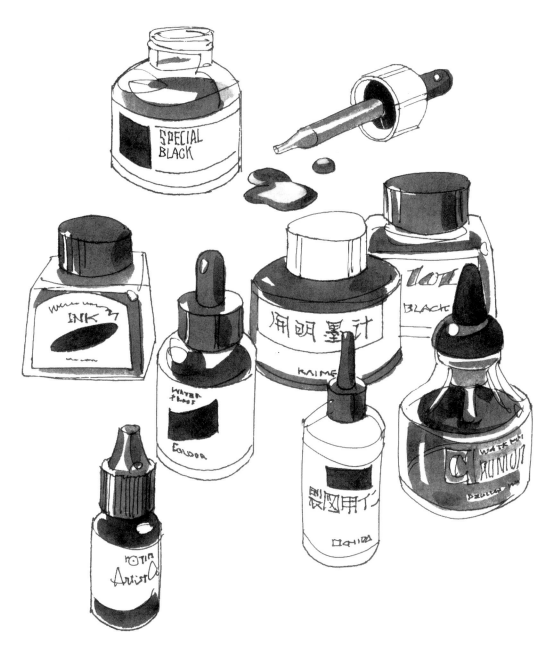

最好選用製圖用墨水或墨汁，乾後不易掉色。

Drafting ink or Indian Ink are the best types of black ink as they are strong once they have dried.

水彩筆
Brushes

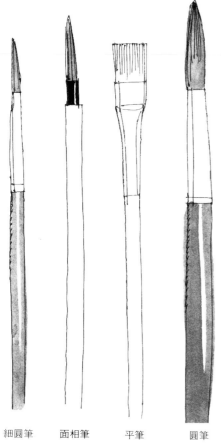

細圓筆	面相筆	平筆	圓筆
Thin Round Brush	Feature Brush	Flat Brush	Round Brush

調色盤：調和顏色、濃淡時用。

Watercolor Palette Dish：This may be used to mix the inks and adjust their density.

滴管：將墨水或水吸到調色盤。

Dropper：This is used to transfer ink or water to the dish.

水溶性墨水加水稀釋後，製造出有濃淡的漸層效果。

Dilute water-soluble ink with water to create a gradation.

乾筆的漸層效果。

Create a gradation using the Dry Brush technique.

要表現筆觸、濃淡層次或平塗時水彩筆可與沾水筆並用。畫筆最好分成黑色專用筆及彩色專用筆。圓筆可平塗、改變筆觸等，用途很廣，也有中號及小號的筆，很方便。另外準備二枝筆，一枝細部平塗用的修飾用畫筆（日本面相筆），一枝沾白色用的修正用筆。

Brushes may be used in conjunction with pens to achieve gradations or areas of flat color. It is a good idea to separate those used for black ink from those used for colors. A round brush is very useful as it may be used to apply a flat coat of color as well as to create variety in the shading, and so it is useful to have both a medium and small size. It is a good idea to have two feature brushes, one to apply flat color in the details and the other for white to make corrections.

筆觸　Brush Strokes

含少量墨水的乾筆。

Dry Brush technique, using only a minimum of ink on the brush.

以手指捏住筆尖、刷出。

Pinch the tip of the brush with the fingers to spread the hairs.

壓在畫面上旋轉。

Press the brush against the paper and revolve.

平筆的平塗。

Flat Blush Storokes.

改變筆觸壓力。

Alter the pressure on the brush.

有速度感的線條。

A line applied with vigor.

紙張對摺，可當成筆使用。

A piece of paper may be folded and used in place of a brush.

白色
White

白色的廣告顏料或膠彩顏料調和成糊狀，以畫筆塗在需要修改之處，修飾成與原紙相同的白色。也有鋼筆用白色墨水，不僅能用於修正沾水筆畫，也能用在新的形體描繪上。

Mix white poster color or gouache to a creamy consistency then use it to cover the areas that have spread outside the outlines and blend them into the white of the paper. White ink is also available that can be used with a pen. In Pen and Ink drawing, white is used not only for correcting but also for lifting out new details.

以白色加上細部描寫
Adding Details with White

用平塗的黑色輪廓表現外型。
Express the shape with a flat silhouette.

重複塗上白色顏料　　Build up with the white.

膠彩顏料
Gouache

廣告顏料
Poster Color

白色墨水
White Ink

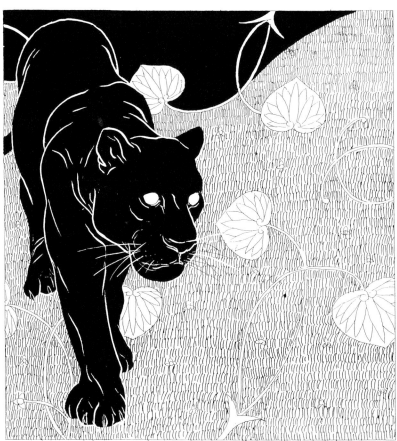

平塗黑色後，在用筆沾上白色顏料描寫細部的黑豹。
The black panther was expressed using white pen lines over a coat of flat color.

14

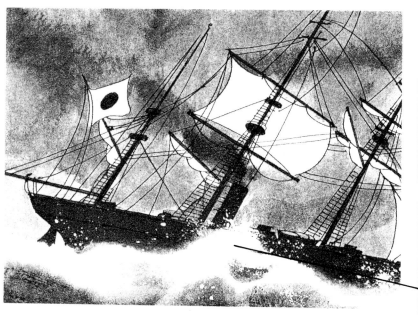

筆尖飽含白色顏料，製造出激越的浪花。

White ink was put on a brush then spattered against the paper to create the spray of the waves.

大面積的修正
Large Areas Correction

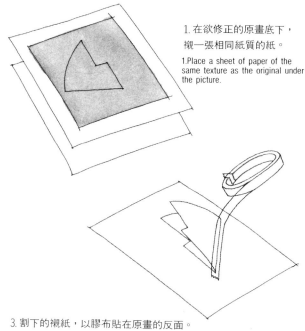

1. 在欲修正的原畫底下，襯一張相同紙質的紙。

1.Place a sheet of paper of the same texture as the original under the picture.

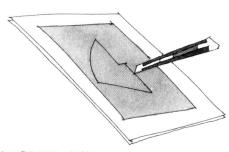

2. 修正處與襯紙一起割下。

2.Cut out the area to be altered, cutting through both sheets of paper.

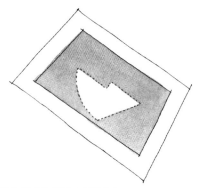

3. 割下的襯紙，以膠布貼在原畫的反面。

3.Turn the picture over then affix the new paper in place of the area of correction with adhesive tape.

4. 原畫修正處已經襯上新的畫紙。

4.The area to be corrected will now have been replaced with fresh paper.

輔助畫具
Supplementary Materials

草圖素描用的鉛筆
A Pencil for the Basic Sketch

　　先以鉛筆畫好草圖，再以沾水筆、黑墨水加上描影，最後以橡皮擦擦掉草圖的線條，沾水筆畫就完成了。草圖素描用的鉛筆最好選擇容易擦掉，筆心較軟，HB～2B的鉛筆。

Pen and ink can be used to go over a pencil sketch then the pencil removed with an eraser afterwards. A soft pencil such as an HB - 2B should be used for the sketch as it is easier to erase.

草圖素描用鉛筆：選擇HB～2B的軟筆心鉛筆較好。

A Pencil for the Basic Sketch : A pencil with a soft lead from HB - 2B is suitable.

橡皮擦：沾水筆描影完成後，擦掉鉛筆草圖。麵包橡皮擦較不傷紙。

Eraser : The pencil sketch can be erased after the ink lines have been applied. The use of a kneadable eraser will keep damage to the paper at a minimum.

鉛筆的草圖素描
The pencil sketch

鉛筆的草圖素描：以鉛筆畫好草圖後，再加上沾水筆的線條。

The pencil sketch : Add the pen lines over the sketch.

油砥石：磨尖筆尖、調整粗細。

Oil stone : This is used to sharpen, widen or make other adjustments to the tip of the nib.

吹風機：吹乾墨水，是沾水筆 畫不可或缺的工具。

Hair Dryer : This is indispensable for drying the ink while working.

圓規類
Rulers and Stencils

徒手畫圓、直線或曲線，看起來較人性化、富親切感。使用尺、圓規等，則使線條看起來冷硬、機械化。可視情形選擇適當的方式。

Straight lines, curves and circles have a warm feeling to them if they are drawn freehand while those that have been drawn using rulers or stencils appear cold and mechanical so their use depends on the job in hand.

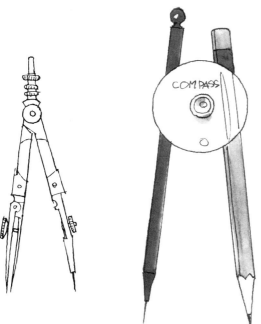

筆及尺的用法　Using a pen with a ruler

筆尖與尺的邊緣要有空隙。

There is a space between the tip of the pen and the point where the edge of the ruler meets the paper.

若沒有空隙，線條會被尺的邊緣擦糊。

Where there is not a space, the ruler will smear the line.

紙張
Paper

製作單色畫時，在此先撇開畫筆不談，可使用不易平塗的肯特紙（製圖紙）、畫圖紙或厚的描圖紙。以沾水筆作彩色墨水線條時可選擇與單色畫相同的紙。若用水彩筆上色，爲提高發色效果，水彩紙爲上上之選。另外，爲防止拿筆的手弄髒畫面時，或沾到手的脂汗而不易上色，最好另舖一張紙以保護畫紙。

When working in black and white, Kent paper, drawing paper or thick tracing paper is to be recommended as the pen will not catch on the texture and areas of flat color can be applied evenly. When the coloring is to be applied only with a pen, the same papers are ideal, but if a brush is to be used, watercolor paper is better as it will permit the true vividness of the inks to be seen. When working, it is easy to smudge the ink with the hand that is holding the pen or for the oil in the skin to coat the paper making it difficult for the ink to take, so it is a good idea to protect your work with another sheet of paper.

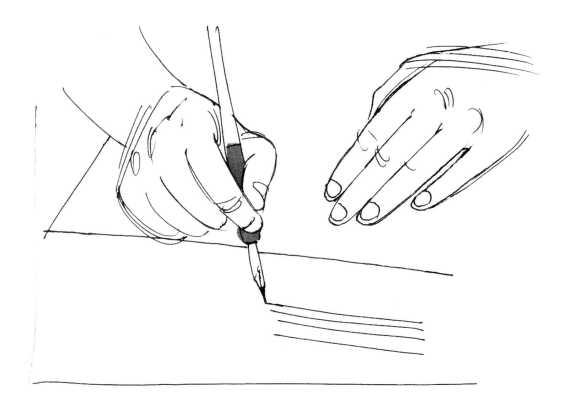

爲了避免弄髒畫紙，另舖紙以保護畫紙。

It is easy to smudge the ink with the round that is holding the pen to protect your work with another sheet of paper.

第二章
沽水筆素描基礎

Chapter 2
The Basics of Pen Drawing

沾水筆的筆法
Pen Strokes

　　除了基本的線與點，還有許多的沾水筆筆法可以廣泛應用在沾水筆畫的表現上。雖然筆法繁多，但並不是每次作畫都要用上每種筆法。在必要時能適當加以組合運用才是重點。

In addition to the basic lines and dots, try variations to the basic shading to widen the range of expression. While there are numerous patterns that can be used when shading, these should not all be used in the same picture, but used in combination with each other as the need arises.

沾水筆的各種線條　Various Pen Lines

| 弱筆壓
Weak Pressure |
| 普通的筆法
Ordinary Pressure |
| 強筆法
Heavy Pressure |
| 點線
Dotted Line |
| 鎖鏈線
Dashed Line |
| 前後重疊線
A Line of Built up Strokes |
| 震動線
Shaky Line |
| 捲曲線
Looped Line |
| 反複強弱的筆壓
A Line with Repeated Heavy and Light Pressure. |

沾水筆的各種筆法
Various Types of Strokes With a Pen

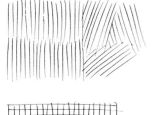

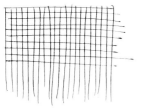

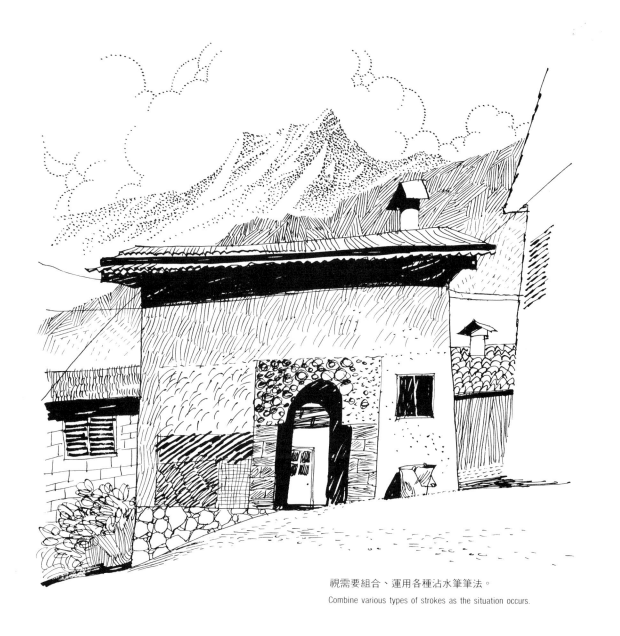

視需要組合、運用各種沾水筆筆法。

Combine various types of strokes as the situation occurs.

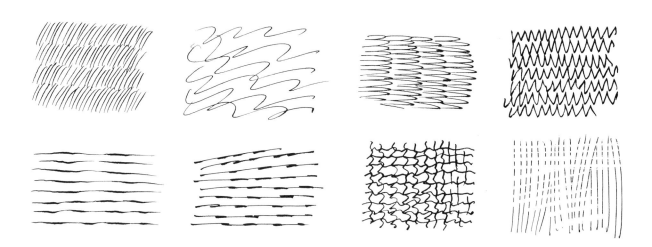

筆壓與筆勢
Pressure and Vigor

使用具有彈性的沾水筆，要能控制筆壓、筆勢，表現富於變化的筆觸。並要能靈活運用，例如保持一定筆壓的均質線條、改變筆勢，具速度感的線條及直線、曲線等。

When using a flexible pen nib, pressure and vigor can be altered to create variety in the strokes. Try drawing a smooth line with even pressure, varying the vigor with which a line is drawn to create a sense of speed then experiment with straight and curved lines to accustom yourself to using the pen.

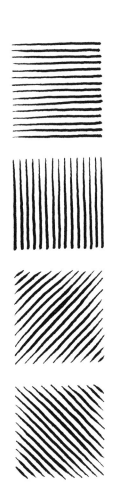

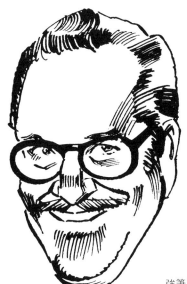

強筆壓的素描
Drawn using heavy pressure.

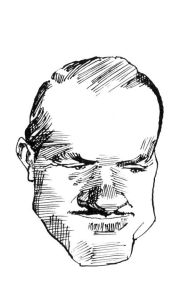

改變筆壓的強弱
Alter the pressure on the pen.

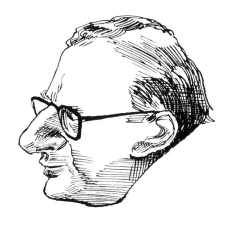

筆勢和緩的素描
Drawn using light pressure.

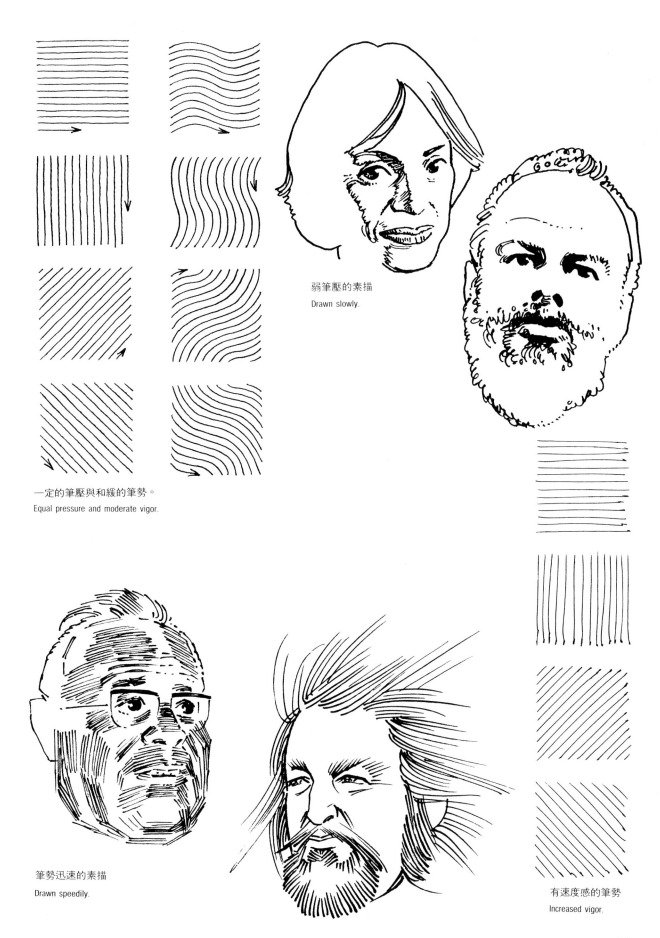

弱筆壓的素描
Drawn slowly.

一定的筆壓與和緩的筆勢。
Equal pressure and moderate vigor.

筆勢迅速的素描
Drawn speedily.

有速度感的筆勢
Increased vigor.

23

以沾水筆表現調子
Creating Shading with a Pen

沾水筆的各種調子變化
Variations in Shading Using a Pen

改變線條的密度。
Alter the density of the lines.

線條交錯的影線。
The lines crossing each other to create cross-hatching.

改變點的密度。
Alter the density of the dots.

改變線的粗細
Alter the thickness of the lines.

改變點的密度
Alter the density of the dots.

改變線的密度。
Alter the density of the lines.

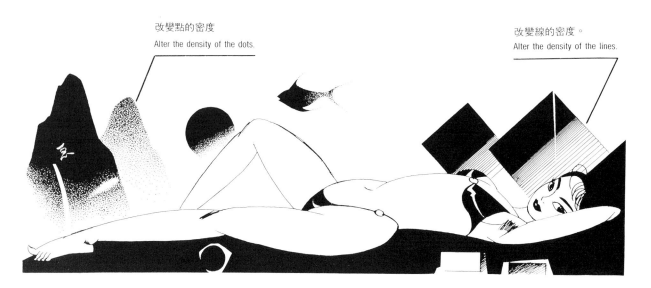

線或點的重疊愈緻密調子愈暗，愈稀疏則愈有明亮之感、要用沾水筆表現單色調子的變化，利用線或點的稀疏、緻密是最基本的方法。若使用水彩筆時，只要以水稀釋顏料，便能控制色彩的濃淡。

The more densely the lines or dots are drawn, the darker the result while the more widely spaced they are, the lighter it becomes. When using a pen and ink the density of the shading is controlled by the spacing of the lines and dots. When using ink with a brush, it should be diluted with water to achieve the desired shade.

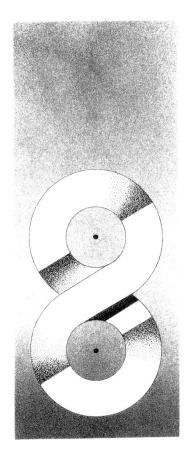

利用漸層網作出霧狀的效果。
Use a gradation screen and spray the ink on the paper.

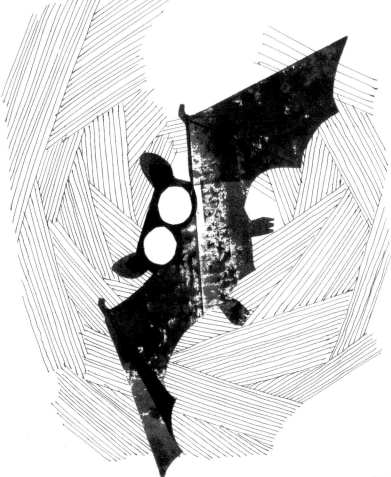

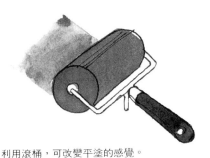

利用滾桶，可改變平塗的感覺。
Run a roller over a flat area of color to create variety.

以沾水筆表現調子

利用直線筆觸表現圓柱。

Straight Lines Used in Shading to Express a Cylinder

1.以背景的筆觸表現圓柱。

1.Use the shading of the background to express the shape.

2.加上陰影。

2.Build up the shading further.

3.加上修飾、使圓柱及背景的空間感更明確。

3.Build up the shading to express a feeling of depth in the background.

4.即使只用直線，只要能掌握調子的明暗，就能表現出圓柱感。

4.If the shading is grasped accurately through the use of straight lines, an expression of roundness may be achieved.

依主體型態表現筆觸

Shading Which Follows the Contours of the Subject

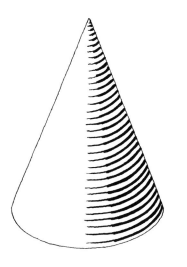

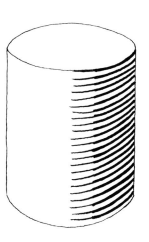

順著主體圓弧而成的曲線，加上粗細變化後，立體感油然而生。

A feeling of depth may be achieved by altering the thickness of the curved lines that follow the contours of the subject.

沾水筆與水彩筆的調子
Shading with Pen and Brush

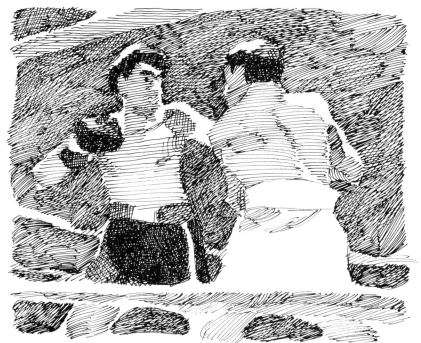

沾水筆的筆觸密度差的表現，
背景的筆觸使人物顯得突出。
Variations in the shading are expressed through the
density of the pen strokes. The shading of the
background makes the figures stand out.

沾水筆：只要明暗掌握得當，即使沒有輪廓線，也能表現立
體感。背景的調子決定了主體的形體。每個形體的明暗用4種
調子表現即可。

Pen : If the shading is grasped accurately, a feeling of depth may be achieved
even without the outlines being expressed. The shape is expressed through
the shading of the background. Each of the objects are expressed through
the use of four types of shading.

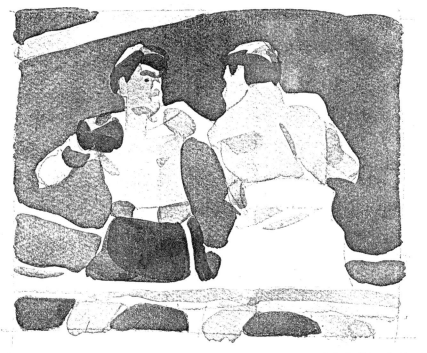

水彩筆：在以水稀釋的中間調子上、再重複加上相同的調子，
可產生與白色畫紙相對比的效果。

Brush : A mid-tone that has been achieved by diluting the ink may be built up
over a previous coat. Effective use should be made of the white of the
paper.

交叉影線
Crosshatching

雪克杯與玻璃杯（使用製圖筆0.5mm）
Drawing a Drink Shaker and Glass (Using a 0.5 m/m. drafting pen)

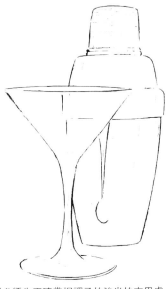

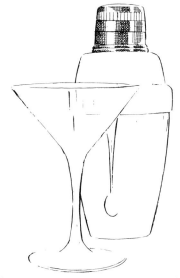

1. 鉛筆草圖必須先正確掌握調子的強光的交界處，再畫出
 輪廓線。透過玻璃杯，可見雪克杯略爲歪曲的輪廓也是
 重點之一。

1.Grasp the areas of the shading and highlights in the pencil sketch then add the outlines with ink. Note the distorted outline of the shaker as seen through the glass.

2. 在有疏有密的直線上，加上斜斜交叉的影線就能表現出
 圓筒型的立體感。

2.The cylindrical shape is expressed through dense vertical shading with diagonal hatching laid over it.

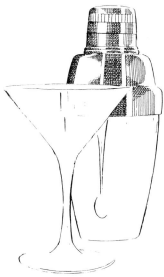

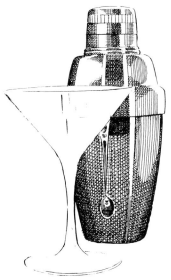

3. 明暗不依的陰影必須與照片吻合。而明暗的交界點不須
 加入輪廓線，只以線來表現才能顯得自然。

3.Refer to the photograph when adding the shading. The reflections look more natural if they are simply added through shading and do not have the outlines drawn in.

4. 以緩和的縱向弧形影線來表現底部的圓形感。

4.The roundness of the base is expressed through the gently curved vertical hatching.

以線條的交叉製造調子、表現立體感是沾水筆畫的基本技法。各位可利用這種技法，嘗試描繪金屬及透明的玻璃。規則的影線及依物體型態而出現的強光都是表現冷硬的金屬與玻璃的重點。

The use of cross-hatching for shading to create a feeling of depth is the one of the basic techniques used when drawing with a pen and here it is used to express metal and glass objects. The hard texture of the metal and glass is expressed through the regular lines of the hatching and the highlights which follow the contours of the object.

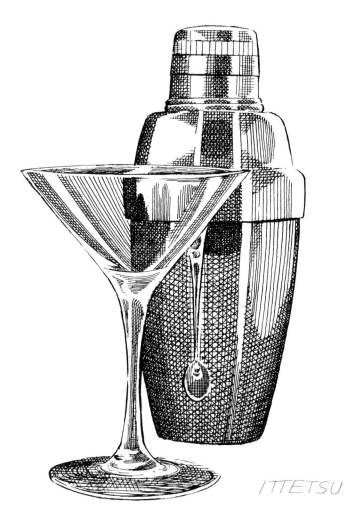

ITTETSU

完成圖：謹慎的影線及透過玻璃杯可見的雪克杯，表現出玻璃的透明感。

The Finished Picture： The transparency of the glass is expressed through restrained hatching and the way in which the shaker can be seen through it.

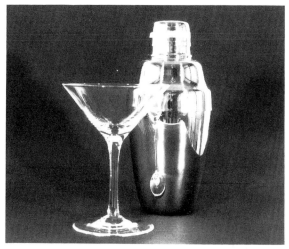

原始照片。
The original photograph.

點描
Pointillism

花朵的細部描寫
A Detailed Sketch of a Flower (Using a round pen)

省略強光部份的輪廓，花瓣的柔和感即可
表現出來。

If the outline is omitted in the highlight areas it
will create a feeling of the soft texture of the
petals.

以花瓣點描的方式，表現留白的花蕊白
線。

When adding the dots for the shading of the petal,
leave the white of the paper to express the pistils.

以點的疏密表現光線的反射。

Express reflected light through the density of the
dots.

點描適合用於細部描寫。點描時需先以鉛筆草圖畫出形狀及陰影的界線，最後的輪廓線則以點表現。這是極需耐心的技法，千萬不可焦燥。

Pointillism is ideal for creating detailed sketches. Before starting work on the picture, make a pencil sketch that grasps the overall shape and areas of shadow. Finish the drawing by adding the outline with dots. This technique requires a lot of patience so one must be prepared to take the time to do it properly.

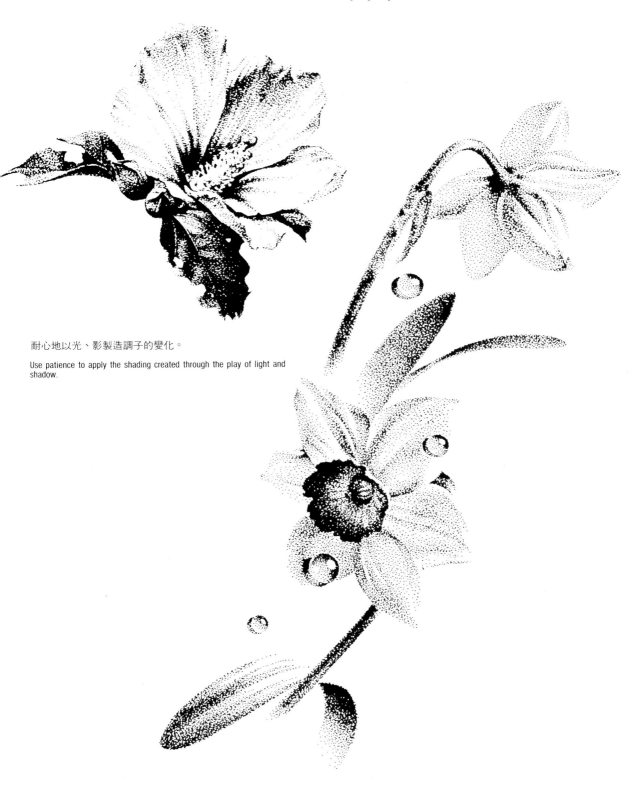

耐心地以光、影製造調子的變化。

Use patience to apply the shading created through the play of light and shadow.

點描與線描
Combining Pointillism and Line Drawing

蚱蜢的細部描寫（使用製圖筆0.1mm）
A Detailed Drawing of a Grasshopper (Using a 0.1 m/m. drafting pen)

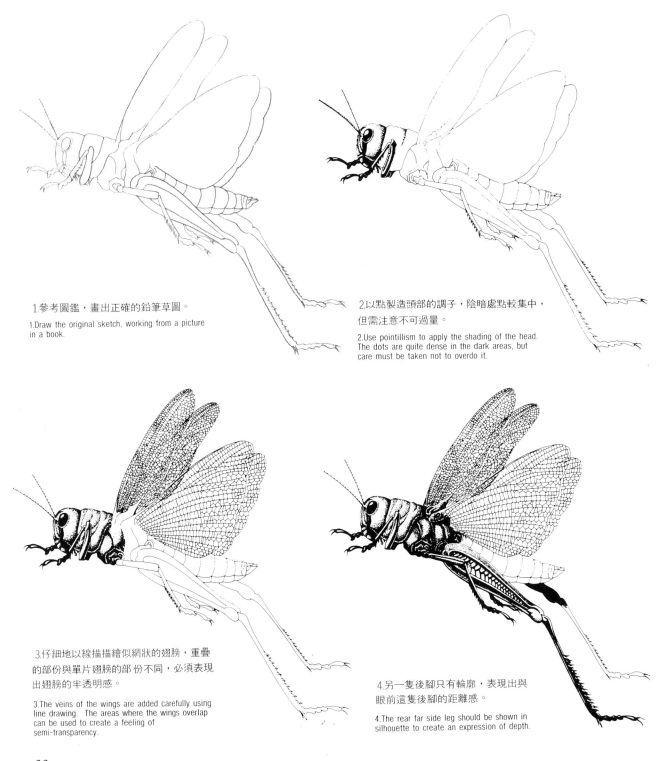

1.參考圖鑑，畫出正確的鉛筆草圖。

1.Draw the original sketch, working from a picture in a book.

2.以點製造頭部的調子，陰暗處點較集中，但需注意不可過量。

2.Use pointillism to apply the shading of the head. The dots are quite dense in the dark areas, but care must be taken not to overdo it.

3.仔細地以線描描繪似網狀的翅膀，重疊的部份與單片翅膀的部份不同，必須表現出翅膀的半透明感。

3.The veins of the wings are added carefully using line drawing. The areas where the wings overlap can be used to create a feeling of semi-transparency.

4.另一隻後腳只有輪廓，表現出與眼前這隻後腳的距離感。

4.The rear far side leg should be shown in silhouette to create an expression of depth.

極細的製圖筆能點出均一的點，適合用於要求精度的
描寫。在這裡，我試著以點描與線條並用的方式，來
做細部的表現。先描出正確的鉛筆草圖，再覆上描圖
紙，耐心的描繪。

A pen with a nib this narrow can create even dots
and is ideal for precision work. Here, line drawing
has been combined with pointillism to create a very
precise expression. Place a sheet of thick tracing
paper over the original pencil sketch and work
patiently on it.

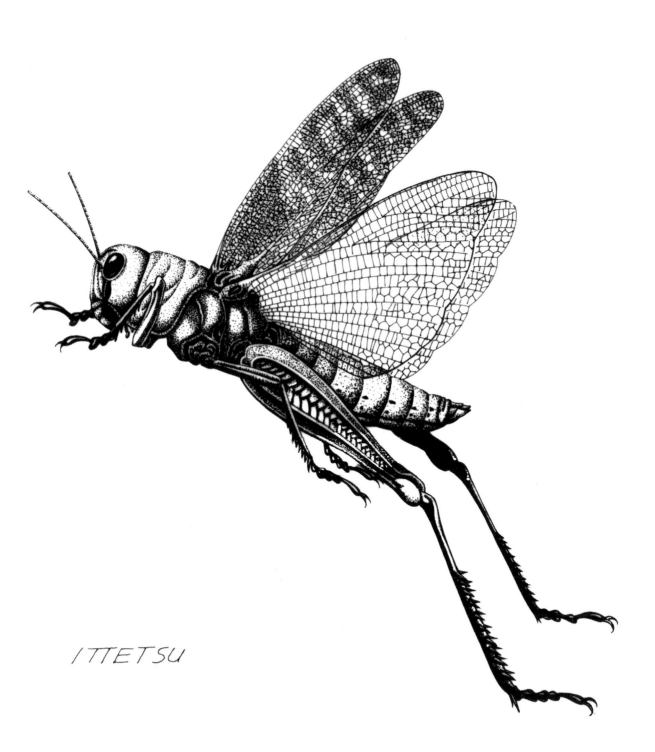

ITTETSU

完成圖：以點描、線描、平塗三種技法表現。

Finished Picture : The subject is expressed using three techniques, lines, dots
and a flat coat of ink.

33

線描與灰色的調子
Line Drawings and Grey Tones

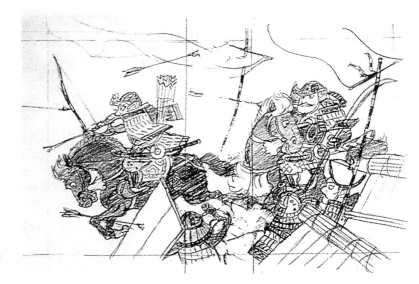

1.鉛筆草圖。在此階段決定全體的調子。

1.Start with a pencil sketch. The distribution of the tones should be decided at this point.

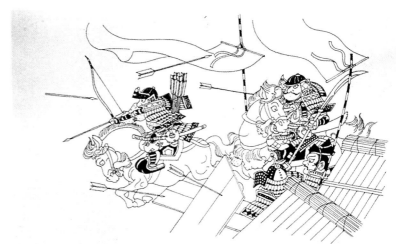

2.描好輪廓線及平塗之後，用橡皮擦擦掉鉛筆草圖的痕跡。

2.After the outlines and the flat tones have been applied, the pencil should be removed using an eraser.

加水稀釋墨水，做出二種灰色調。

Dilute the ink to create the two tones of grey.

試著以平塗、線的黑色及二種灰色調、畫紙的白色，四種調子表現整幅畫。爲了避免破壞線條，線描需用耐久性墨水。

This picture was created using lines and four tones, flat black, two greys and the white of the paper. Waterproof ink should be used in order to avoid the lines being smudged when the flat tones are applied.

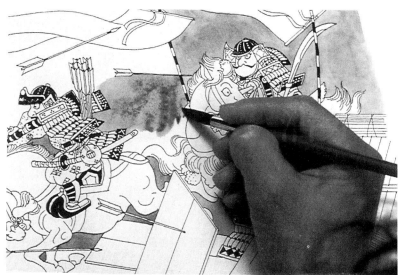

3.塗上明亮的灰色調，爲了避免墨水積蓄在紙上形成斑駁的顏色，上色時要迅速。

3.Apply the light grey tone. This should be done rapidly to avoid unevenness in the ink.

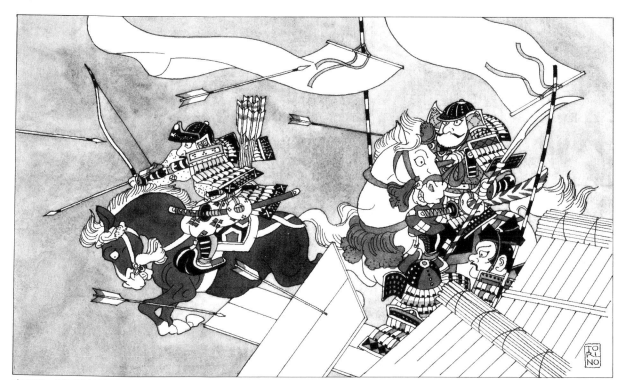

完成圖：運用畫紙的白色效果也是黑白表現的重點之一。

Finished Picture : The important thing when creating a monochrome sketch is to take maximum advantage of the white of the paper.

掌握基本構造面
Understanding the Planes

線條的筆觸
Lines

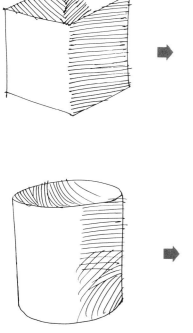

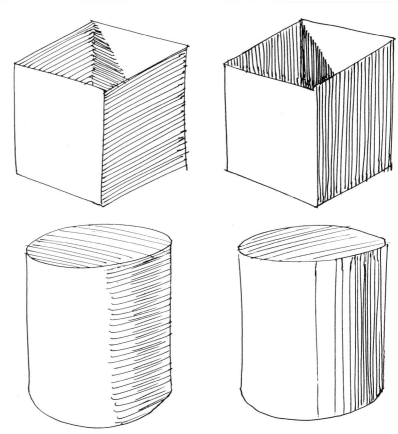

曖昧不明的筆觸會減弱形態感。

If the lines are added in a half-hearted fashion, the shape will become vague.

筆觸順著物體的面、會使形態感更明確。

If the lines are drawn following the surface of the object the shape will become clear.

點描
Pointillism

最好先理解物體的面所呈現的方向，再描繪製作光和陰影的調子。

Once the flow of the planes has been comprehended the shading may be added to express the highlights and shadows.

在圓形的物體上，加上順著物體圓弧的筆觸，更能強調出立體感及形態感。並掌握物體的基本構造曲面，了解光和陰影的關係來表現形態感。

The shading of the round objects should follow the contours in order to grasp both the depth and shape of the subject. At the same time, one should break a subject down into its basic planes in order to express its form and understand·the relationship between light and shade.

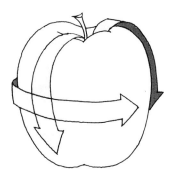

理解球體構造曲面的方向，加入光與陰影的調子，更能強調立體感。

If the flow of the planes of the globe are understood before the shading is applied, a greater sense of depth may be achieved.

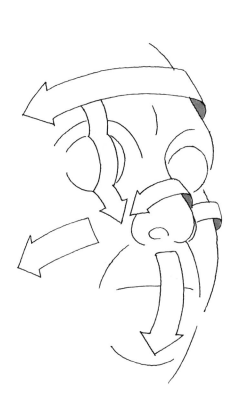

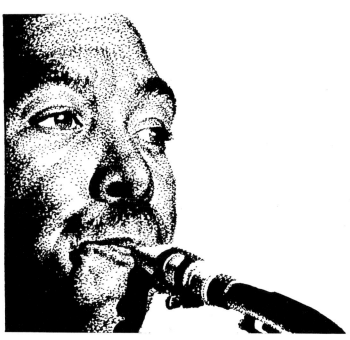

掌握臉部的基本構造曲面，理解在構造面上光和陰影的方向，就能表現立體感。

Grasp the basic planes of the face. Express the sense of depth remembering that the light and shade follows the direction of the planes.

順著臉部構造的描影（使用製圖筆0.5mm）

Shading Along the Contours of the Face (Using a 0.5 m/m. drafting pen)

讓我們以順著臉部構造的線條，來描繪嬰兒吧！由於
鋼筆的線條較剛硬，如果在臉部加上太多的線條，會
減低嬰兒的可愛感，因此，重點在於儘量省略不必要
的線條，掌握重要之處即可。

Let's try drawing a baby with the shading following
the contours of the face. Pen lines are very strong
so care must be taken not to overdo the shading or
it will deduct from the appeal of the subject.
Simplify the picture as much as possible and only
focus on the main points of interest, grasping them
as planes

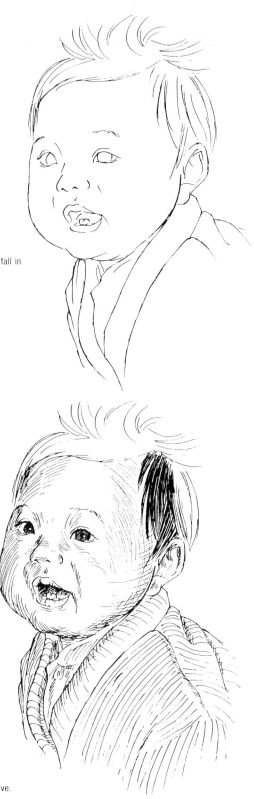

1.鉛筆草圖。嬰兒的眼、鼻位於中央位置。

1.Start with a pencil sketch. In the case of a baby, the eyes and nose fall in
the center of the face.

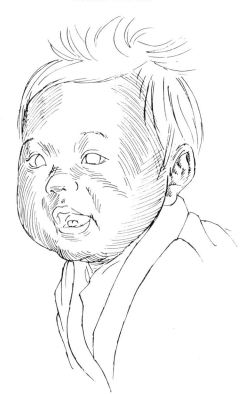

2.沿著表面加上線條，要抓住臉的形態感。

2.Add shading following the planes of the face to grasp the feel of the
shape.

3.在眼睛加上強光部，表情更生動。

3.If a highlight is added to the eyes, the subject seems to come alive.

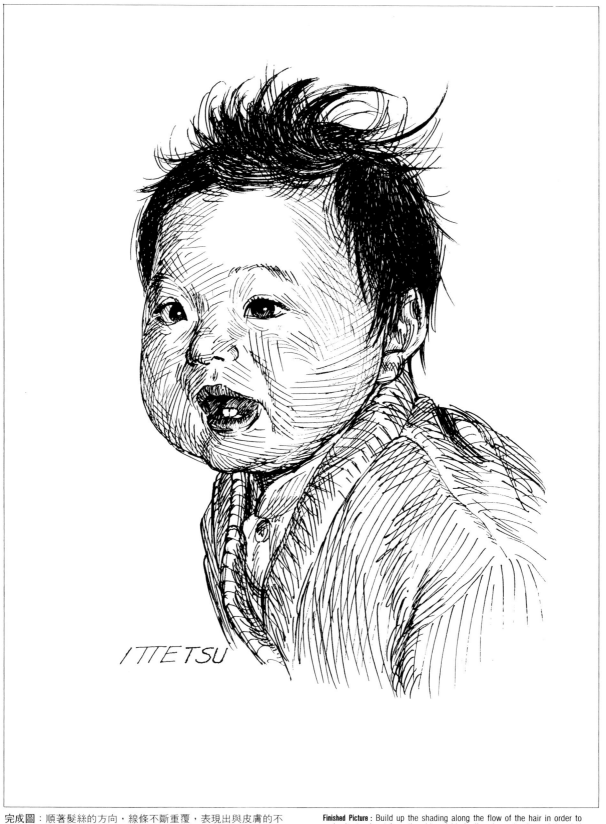

ITTETSU

完成圖：順著髮絲的方向，線條不斷重覆，表現出與皮膚的不同之處。衣服上也加上了順著布料方向的描影。

Finished Picture : Build up the shading along the flow of the hair in order to make it stand out from the skin. Add shading down the flow of the clothes.

掌握基本構造面

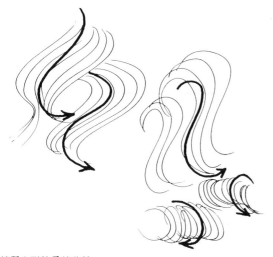

練習 S 形的柔軟曲線。

Practice drawing gentle S-shaped curves.

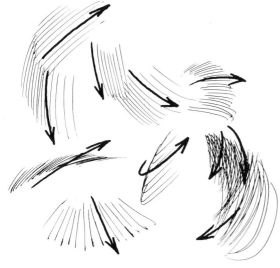

具有立體感的頭髮,在一定的方向,不斷加上流暢的線條。

A sense of depth in a person's hair can be achieved by building up a flowing shading in a single direction.

布料皺摺的基本構造曲面,在布料的懸垂方向加上重覆的描
影,表現立體感。

Grasp the folds in material as a plane and build up the shading along the direction of its movement to create a feeling of depth.

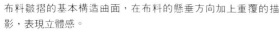

仔細觀察布料及頭髮，就此分辨其中的紋理走向。掌握這些走向的基本構造曲面，加上疏密有別的描影，就能自然顯出立體感。

If you study material or hair, you will notice that there is a flow and rhythm to it. If you grasp the direction of the flow as a plane and control the density of the shading along it, you will automatically achieve a sense of depth.

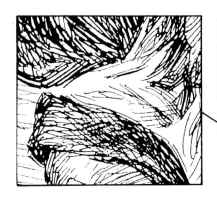

沿著曲線起伏的線條顯出立體感。

The flow of creases in clothes caused by the wearer's movement is expressed through line shading.

以描影表現因人物的動作而顯出的皺摺順著腿部圓弧感加上描影。

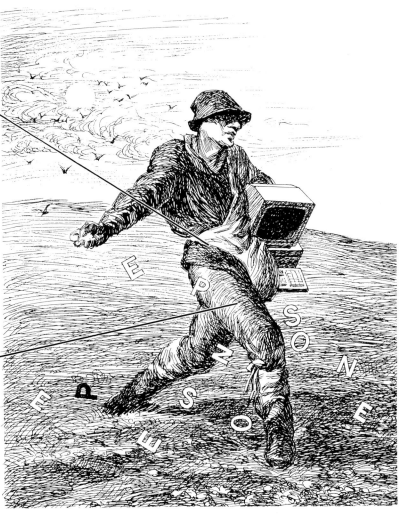

沿著曲面的線表現出立體感。

The round objects should follow the con tours in order to grasp both the depth and shape of the subject .

尺的使用
Using a Ruler

表現金屬質感（使用0.1mm製圖筆）
Expressing the Texture of Metal (Using a 0.1 m/m. drafting pen and brush pen)

利用各種尺所畫出的直線或曲線，與徒手畫的線相較
之下，顯得冷硬、無生命感。適合用於工業製品及建
築物透視圖的描繪。

Lines can be drawn using a variety of straight or
curved rulers but the result always appears colder
and more mechanical than that achieved through
freehand. For this reason they are ideal for
technical illustration or architectural sketches.

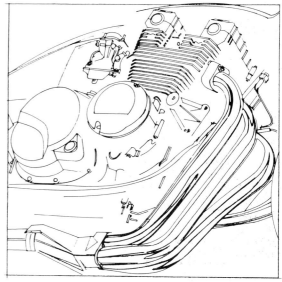

1.使用製圖尺作成的鉛筆草圖。消音器的曲線，是用厚
紙做成尺所畫成的。

1.Draw the basic sketch using a pencil and ruler. The curve of the muffler
was drawn using a stencil cut from cardboard.

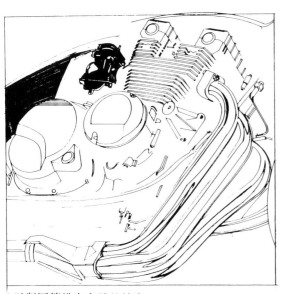

2.以製圖筆描出全體的輪廓。

2.Go over the outline using a drafting pen.

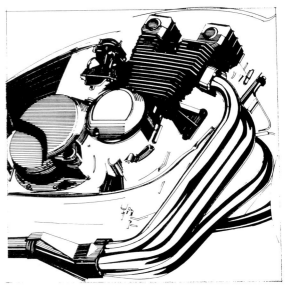

3.消音器上的線條、表現出金屬的材質感。強調明暗的
對比是一大重點。

3.The metallic feeling of the exhaust pipe is accentuated by the strong
contrast and the addition of reflections in its surface.

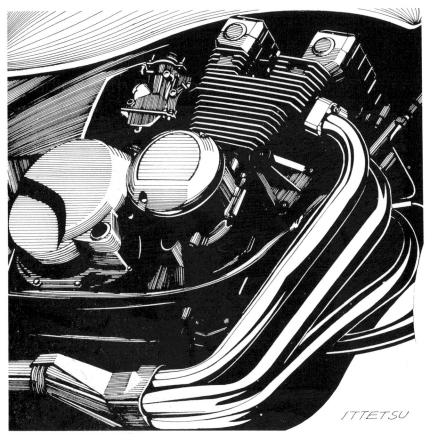

ITTETSU

完成圖：利用製圖筆與尺畫出的直線，表現出冷硬的金屬質感及速度感。平塗的部份是以軟筆塗成的。

Finished Picture : The use of a drafting pen and ruler produced a sharp, metallic texture and created a feeling of speed. The area of flat color was added using a brush pen.

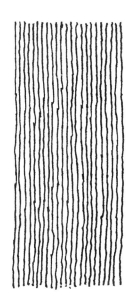

以尺畫出的線（左）與徒手畫線相比，顯得冷硬無生命感。

The line which was drawn with a ruler (left) is more mechanical than that which was drawn freehand (right).

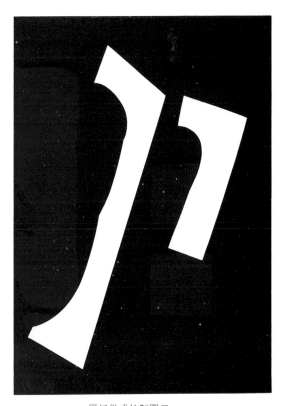

厚紙做成的製圖尺。

A ruler that was cut from a sheet of cardboard.

使用自來水筆
Using a Brush Pen

自來水筆就像鋼筆一樣，內有墨水，因此能一口氣畫出粗線或平塗，很方便。圖例中，先以自來水筆塗好暗部，再以沾水筆慢慢地描繪中間調子，即能顯出效果。

A brush pen has an internal supply of ink which makes it very useful for drawing broad lines or creating a flat area of color. As can be seen from the example, it is very effective if it is used to fill in the dark areas first before gradually adding the mid-tone with a dip pen.

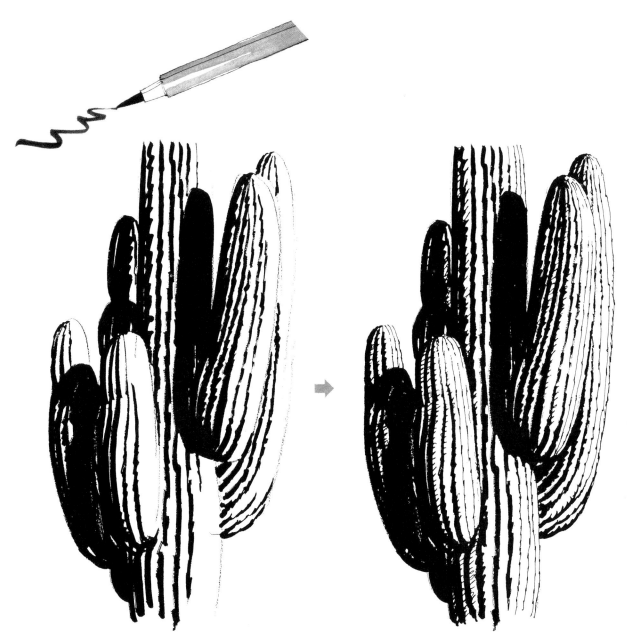

在鉛筆草圖上，一口氣描繪出仙人掌的陰影。

The shadow areas of the cactus were added to the pencil sketch using a brush pen.

交互使用自來水筆和乾筆平塗後，再加上鋼筆線條。

After the flat area has been applied using a brush pen and dry brush, the drawing can be added using a dip pen.

44

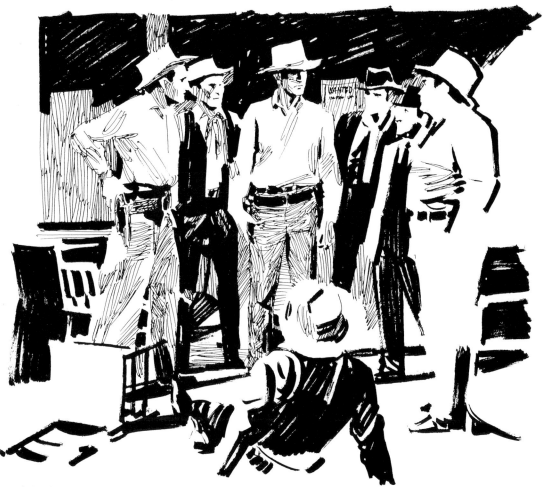

以自來水筆做暗部平塗後再以圖筆加上中間調。

A brush pen was used to apply the dark areas then a round pen was used to add the mid-tone shading.

以自來水筆描繪輪廓線後，再以稀釋的墨水加上中間調。
A brush pen was used to apply the outline then the mid-tones were added using diluted ink.

使用麥克筆
Using a Felt-tip Pen

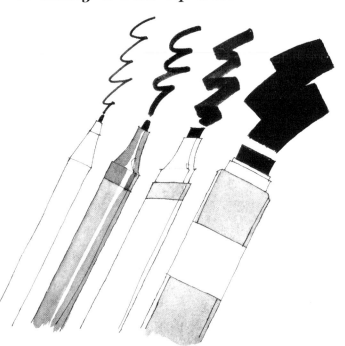

1.以鉛筆做草圖素描。
1.Draw the basic sketch with a pencil.

2.在草圖上覆上描圖紙,用二種灰色油性麥克筆、描繪形狀及明暗的調子。
2.Place a sheet of tracing paper over the sketch then use two oil-based felt-tip greys to fill in the shape and tones.

3.最後加上強烈的黑色調,使形體顯得更俐落後即告完成。
3.Add some deeper black shading to produce an accent in the picture and it is complete.

粗的麥克筆也有各種灰色調，只以黑白表現作品時，
反覆塗上這種灰色，就能製造出較暗的調子。

Felt-tip pens come in a variety of sizes and tones of
grey. When making a black and white drawing,
these greys can be built up to create an even darker
tone.

使用三種調子
Drawn Using Three Types of Shading.

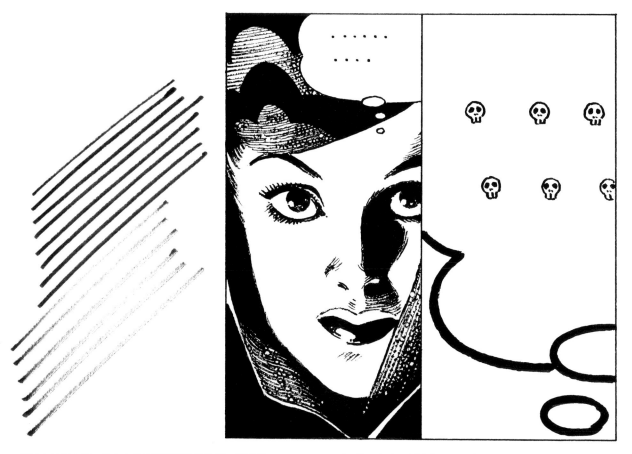

舊的水性麥克筆，畫出來的線條頗有乾筆風格，很有趣。

An old, water-based felt-tip pen may be used to create an interesting
dry-brush effect.

畫具的配置
The Layout of Materials

畫具、工具的配置有利於作品的製作。用右手操作的器具就放在右邊，在使用上會比較方便。使用頻繁的黑墨水可在瓶底貼上雙面膠，黏在便於使用之處，就不需擔心會打翻了。如果有描圖用的燈箱，製作作品時就更方便了。

The materials should be laid out in such a way as to make it easy to work. If the items that you use in your right hand are placed on the right side, it will allow you to work smoothly. If the bottle of black ink which is most frequently used is fastened to the desk in a convenient position with double-sided tape there will be no danger of knocking it over while you work. A light box is useful when tracing a sketch.

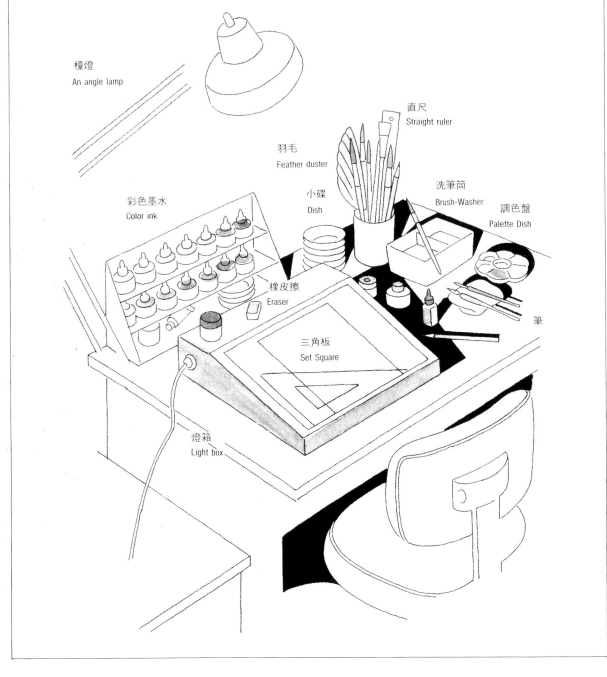

檯燈
An angle lamp

羽毛
Feather duster

直尺
Straight ruler

彩色墨水
Color ink

小碟
Dish

洗筆筒
Brush-Washer

調色盤
Palette Dish

橡皮擦
Eraser

筆

三角板
Set Square

燈箱
Light box

第三章
彩色墨水基礎

Chapter 3
The Basics of Color Ink

彩色墨水的特徵
The Characteristics of Color Ink

彩色墨水的特徵在於其卓越的發色力與透明性。其中分爲可以水稀釋，乾後變爲水性及乾後再上色仍可混色的水溶性二種。初學時，選用耐水性可重疊色彩的彩色墨水較容易學習。

Color inks have excellent color brilliance and transparency. They may all be diluted with water but some of them become waterproof when they dry while others dissolve and blend with inks that are applied over them. In the beginning it is probably easiest to use water-resistant inks as these may be used to create a glazing effect.

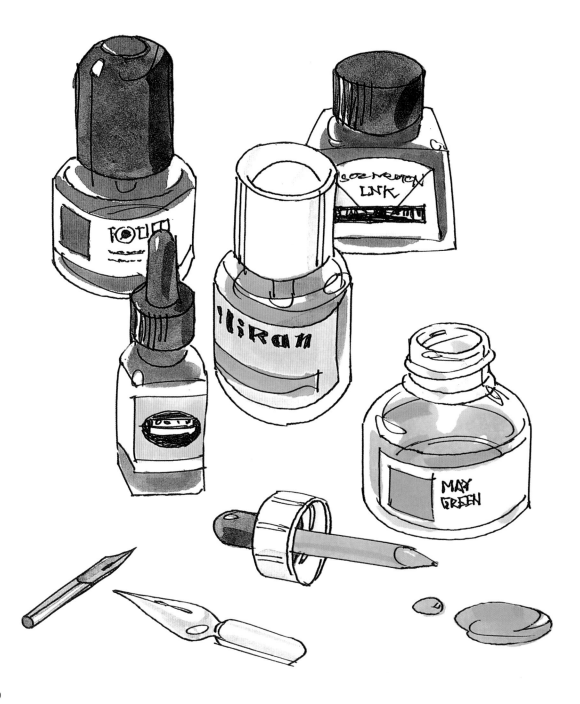

發色效果
The Color Brilliance

利用彩色墨水發色性良好、高彩度的色徵，配上補色後與鄰近的顏色引起反射，發生光暈。此處的畫例使用原始顏色及加水稀釋的顏色。

In order to take advantage of the brilliance and high color saturation of the inks, complementary colors should be used together. The adjacent colors attempt to repel each other, creating halation. In the example shown here, I have used both diluted and undiluted inks.

原始的顏色
Undiluted color.

彩色墨水即使以水稀釋後仍能保持發色效果。

Even when color ink is diluted, it does not lose its brilliancy.

以水稀釋後的顏色
Diluted color.

彩色墨水的特徵

稀釋後上色

如果彩色墨水顏色過濃，可加水調和，創造出明亮的
膚色或陰影中較暗的膚色。

Coloring with Diluted Ink

If the color of the ink is too dark, it may be diluted
with water. In this way it is easy to achieve both
light skin tones and dark tones for the shadow
areas.

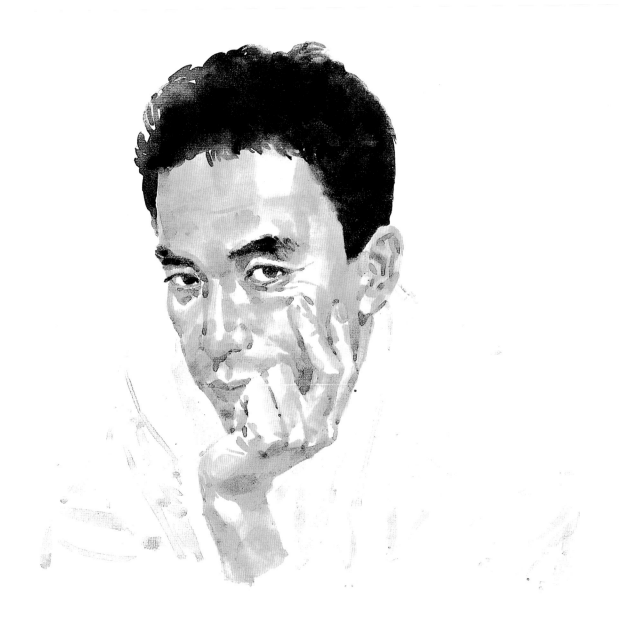

用於膚色上的原始顏色。

The original color of the ink used for the skin tones.

沾水筆畫出的影線

以沾水筆畫出不同顏色的影線，會產生視覺上的混色效果。這裡的畫例是五種顏色的影線。

Crosshatching with a Pen

A pen can be used to produce crosshatching using different colors and this creates an illusion of mixed color. In the example, five colors were used in the crosshatching.

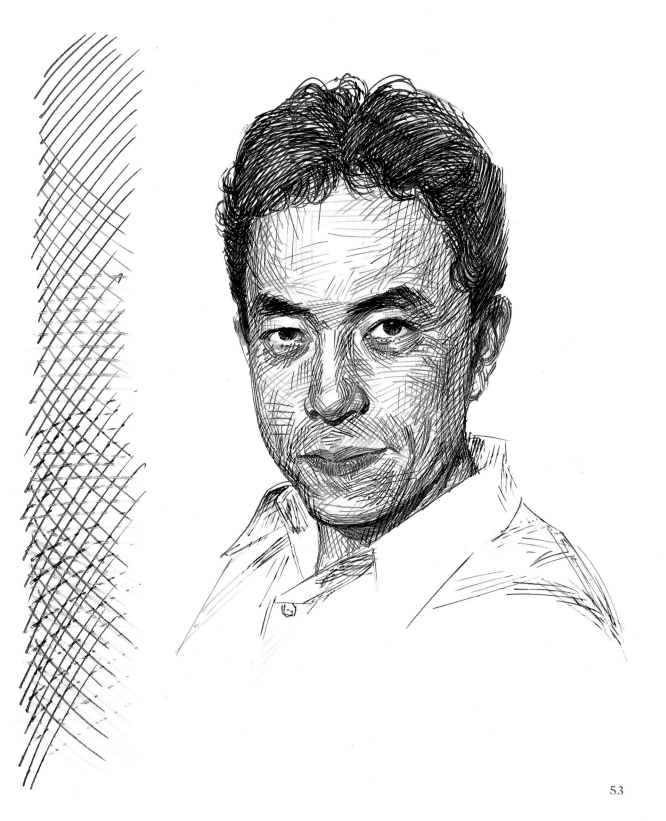

彩色墨水的特徵

運用墨水的透明性
Utilizing the Transparency of the Ink

彩色墨水亦稱為液體透明水彩，色彩重疊時，會產生彷彿透過玻璃紙般的混色效果。運用這種效果，能製造出深色、透明的色調。

Color inks are sometimes referred to as liquid transparent watercolors and when one color is laid down over another, it is like looking at the first color through colored cellophane. When using colored inks this property should be utilized to create a deep, transparent tone.

在底色上疊上另一種顏色，即可見到混色效果。

The base color and the upper color appear to mix.

以疊色的方法，創造微妙的色調。

Colors may be built up to create delicate tonal variations.

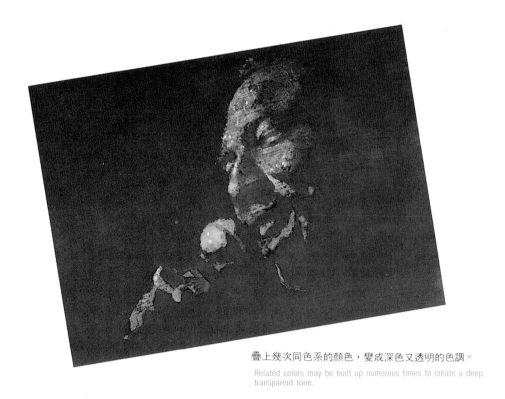

疊上幾次同色系的顏色，變成深色又透明的色調。

Related colors may be built up numerous times to create a deep transparent tone.

即使上色後，仍不會掩住事先畫好的線條。

Even when colors are built up over a line, it remains visible.

以水彩筆上色
Coloring with a Brush

膚色的調法

How to make the skin tone.

以紅色爲基調色。

Red is the base color.

攪入一點黃色及綠色。

Addsmall quantities of yellow and green.

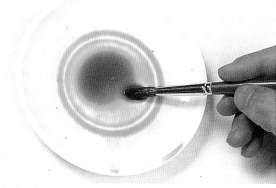

加水調色。

Dilute with water to achieve the required color.

1.鉛筆草圖。

1.The original sketch is drawn with a pencil.

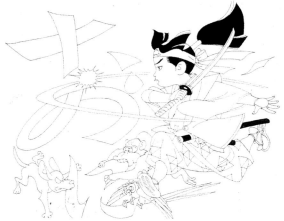

2.以彩色墨水描出輪廓線後,再加上黑色、平塗。二者均使用耐水性墨水。

2.After drawing the outline using colored ink, the areas of flat black are added. All the ink used at this point should be waterproof.

3.塗上調好的膚色。

3.Paint a skin tone that was created through mixing.

你可以試著以彩色墨水加上輪廓線，再以水彩筆上色，除了以圓筆畫出的輪廓線外，其他以水調和的顏色仍不減彩色墨水的彩度及透明度。即使使用耐水性墨水，仍必需等先前的顏色乾後再上其他顏色。

Try drawing the outline with color ink then using a brush to add the color. Apart from the lines that are drawn using a round nib, the colors should be mixed and diluted to achieve the required color but this should not result in a loss of color saturation or transparency. Even when using water-resistant ink, it is important to ensure that the base color has dried before going over it with another color.

4.用紅色彩色筆在臉頰上再塗上顏色。

4.Build up the red of the cheeks using a red pencil.

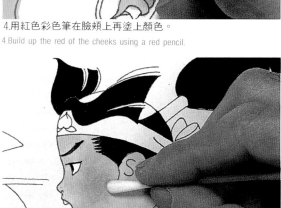

5.以棉棒塗暈紅色。

5.Blend the red using a tortillon.

完成圖

Completed Picture

渲染
Wet-in-wet

先用含水的水彩筆濕潤要上色的部份，再以沾水筆或水彩筆上色，會使顏色暈開，產生與單純地上色不同的效果。另外，在乾的彩色圖面上，滴上水份，則會造成與前者不同風格的畫面。

If the area to be colored is moistened with a wet brush first, when the ink is applied with a brush or pen, the color will run and produce a different effect to simple coloring. Again, if water is dropped on an area of coloring before it has quite dried, it will create yet another effect.

水彩筆
Brush

沾水筆
Pen

以沾水筆點出的效果
Dabbing with a Pen

在已濕潤處上色

Applying color to a
moistened area

在乾後的彩色圖面上滴上水份。

Dropping water on an area of color that has not
yet dried.

在乾後的彩色圖面上再以沾水筆圖上顏色。

Coloring with a pen on an area of color that has
not yet dried.

在乾後的彩色圖面上，滴上其他顏色。

Dropping a second color on an area of color that
has not yet dried.

暈色
Color Gradations

暈色分爲以含水的彩筆刷在已乾的彩色圖面上，及先
打濕畫面再使色彩暈開二種。

There are two ways of creating a gradation, the
edges of a color may be gone over with a wet brush
before it has completely dried, or the paper can be
dampened before the ink is applied.

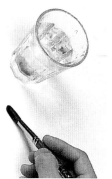

要暈色的部份先以含水的彩筆打濕。

Use a brush to moisten the area which is to have
the gradation.

上色。

Add the color.

顏色漸漸暈開。

The color becomes gradually lighter.

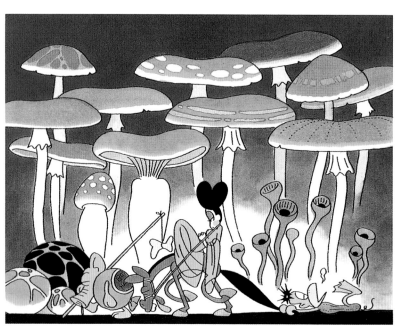

背景暈色的畫例。

Gradation of background.

趁墨水未乾之際,以含水的彩筆輕刷,
使顏色暈開。

A wet brush is used to blur the ink before it has
dried.

混色
Mixing Colors

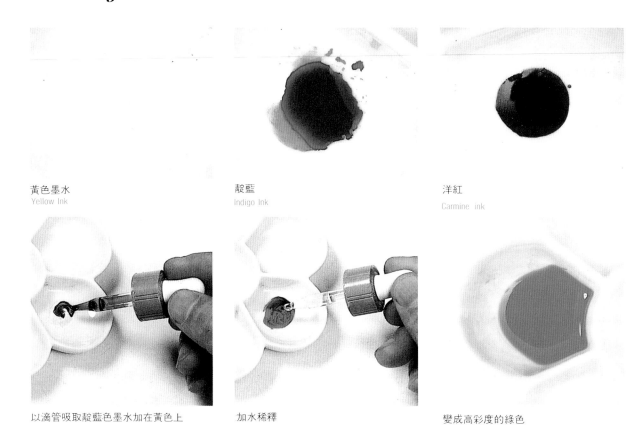

黃色墨水
Yellow Ink

靛藍
Indigo Ink

洋紅
Carmine ink

以滴管吸取靛藍色墨水加在黃色上
Add indigo to the yellow

加水稀釋
Add water to dilute the ink.

變成高彩度的綠色
A green with a high color saturation is achieved.

即使二色混合彩度也不會降低
Even if two colors are mixed, the color saturation is not effected

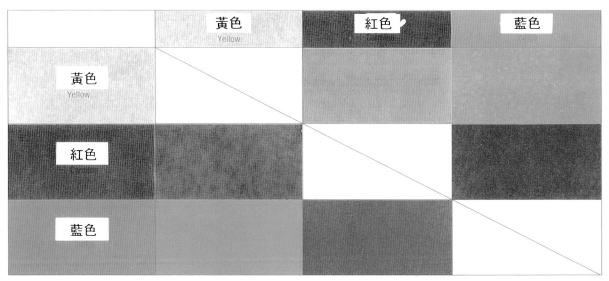

	黃色 Yellow	紅色 Carmine	藍色
黃色 Yellow			
紅色 Carmine			
藍色			

試試看，在調色盤中加入二種顏色，創造另一種新顏色。混合二種顏色，彩度仍不會降低是彩色墨水的優點，增減墨水量會使顏色產生微妙的變化，只要多試幾次，習慣後就能隨心所欲的運用。

Try mixing two colors in a dish to create a new color. One of the advantages of using colored ink is that if only two colors are mixed, it will not effect the color saturation. Small differences in the amount of ink used will create minute differences in the final color so plenty of practice is recommended in 'order to learn to control this.

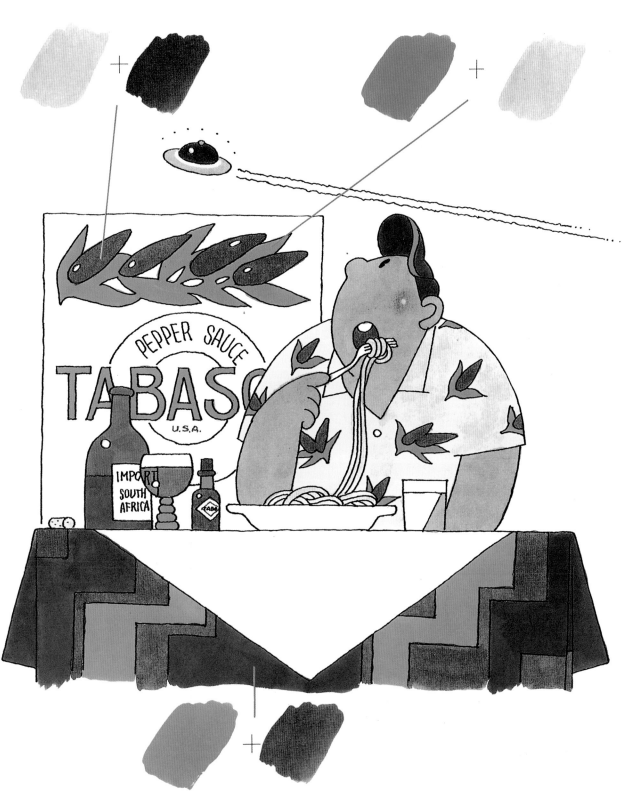

63

沾水筆上色
Coloring with a Pen

沾水筆的使用
Using a Pen

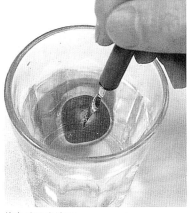

換色時以水清洗。

When changing colors, wash the nib in water.

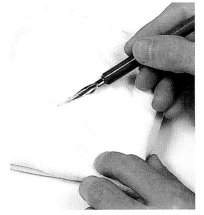

在布上擦掉殘餘的顏色。

Wipe the tip of the nib with a cloth.

線的混色
Mixing Colors Through Lines

以不同的顏色畫出橫線和直線,看起來
就像布料般。

Use different colors for the vertical and horizontal lines, like the warp and weft of cloth.

點的混色
Mixing Colors Through Pointillism

依點的比例改變顏色

The color is decided by the ratio of colored dots.

墨水直接沾在筆上所畫出的線條，既能表現力道，亦能表現纖細感。不同顏色的影像或點描，能產生視覺上的混色效果。這是只有彩色墨水沾水筆才有的效果，試試看吧！筆要分為寒色系用及暖色系用，要經常保持筆尖乾淨，避免殘留墨水使顏色混濁。

Drawing directly with a pen allows the creation of both strong and delicate lines. Hatching or pointillism with different colored inks produces an illusion of mixed color and permits expressions that cannot be achieved through any other medium. When working with colored inks, you should keep one pen for warm colors and another for cold colors, occasionally wiping the tip of the nib to prevent the ink in the pots becoming contaminated.

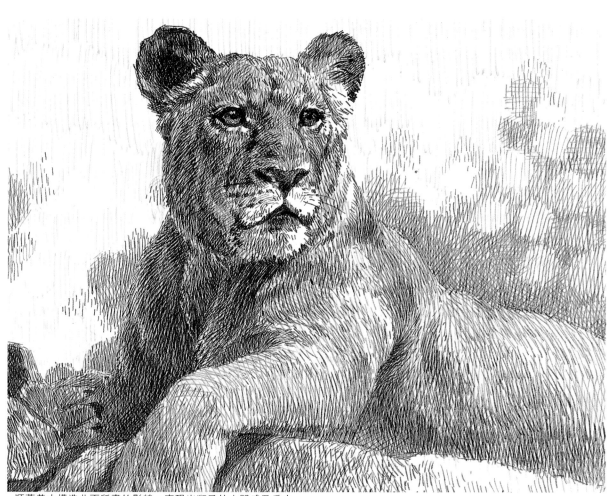

順著基本構造曲面所畫的影線，表現出獅子的立體感及毛皮感。
The lines following contours of the lion create a feeling of depth while expressing the texture of its coat.

線條與上色
Line and Coloring

沾水筆的筆觸與彩色墨水

以沾水筆及黑墨水表現的穩固銳利線條，以及在彩色圖面上加入柔和的曲線或細膩的筆觸，會使作品顯出更明確的個性。另外，黑墨水的果斷、強力，以彩筆上色後，更具有突顯、振奮之功用。但黑墨水必須使用耐水性墨水。

Pen Strokes and Colored Ink

The hard, sharp lines, the soft lines and the fine shading that are associated with pen and black ink drawing may be adopted in colored areas to create a distinctive illustration. The strong lines of the pen provide an accent which will draw a brush picture together. It is important that the black ink used should be water-resistant.

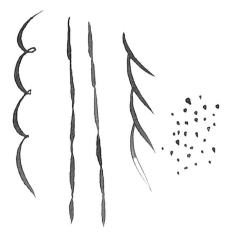

G筆：以筆壓強弱變化線條。

G Pen : Differences in pressure provide variation in the lines.

以輪廓線的粗細、點或細膩的筆觸創造表情。

The different thicknesses in the outline, the dots and fine shading that create the characters' expressions.

加上輪廓線，表現細微的形體動作。

Used to add the outlines and delicate shapes.

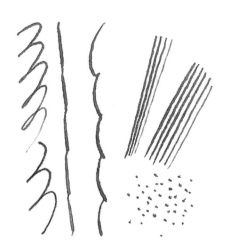

沾水筆：很普遍的畫筆。以G筆相同，以筆壓的強弱變化線條。

Spoon Pen : This commonly used pen is similar to the G pen in that differences in pressure produce variation in the lines.

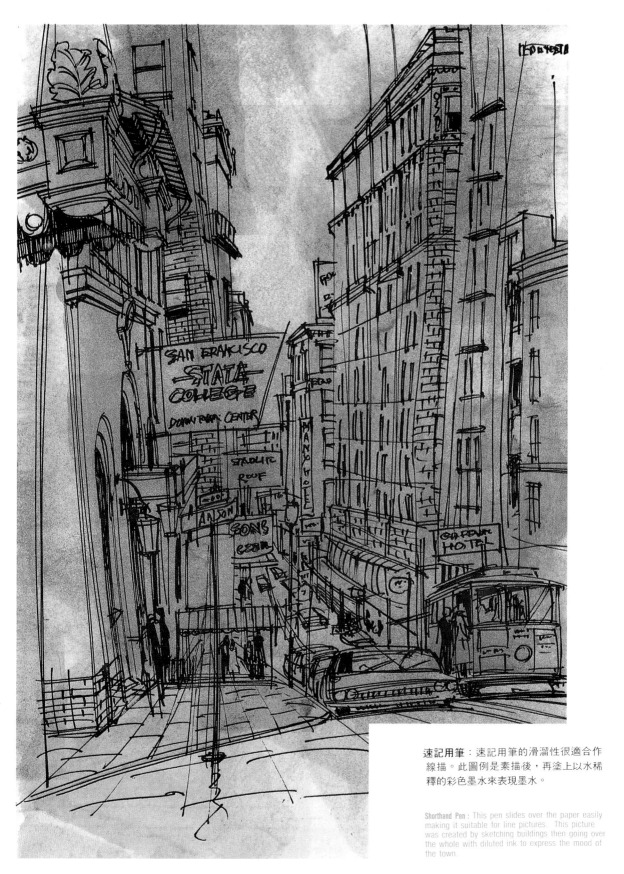

速記用筆：速記用筆的滑溜性很適合作線描。此圖例是素描後，再塗上以水稀釋的彩色墨水來表現墨水。

Shorthand Pen : This pen slides over the paper easily making it suitable for line pictures. This picture was created by sketching buildings then going over the whole with diluted ink to express the mood of the town.

單色的影線效果
The Effect of Single-Color Hatching

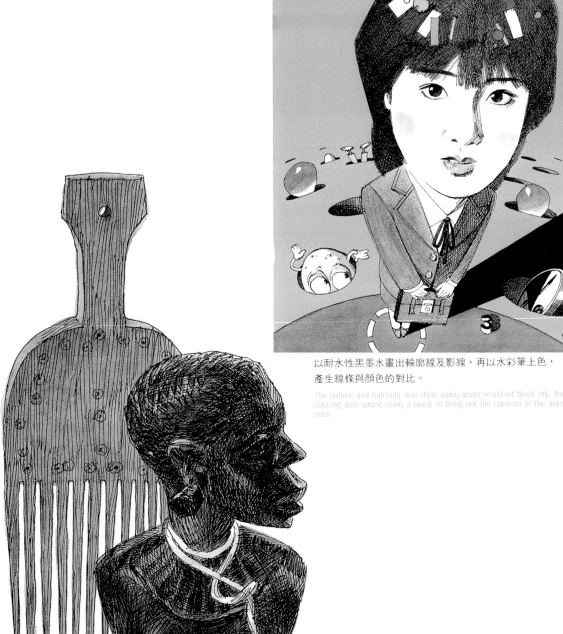

以耐水性黑墨水畫出輪廓線及影線,再以水彩筆上色,
產生線條與顏色的對比。

The outline and hatching was done using water-resistant black ink, then the
coloring was added using a brush to bring out the contrast of the lines and
color.

以水彩筆上色後再以黑墨水,順著基本構造曲面畫出影
線表現立體感。

After the color was applied with a brush, black ink was used to produce
hatching around the outline and create a feeling of depth.

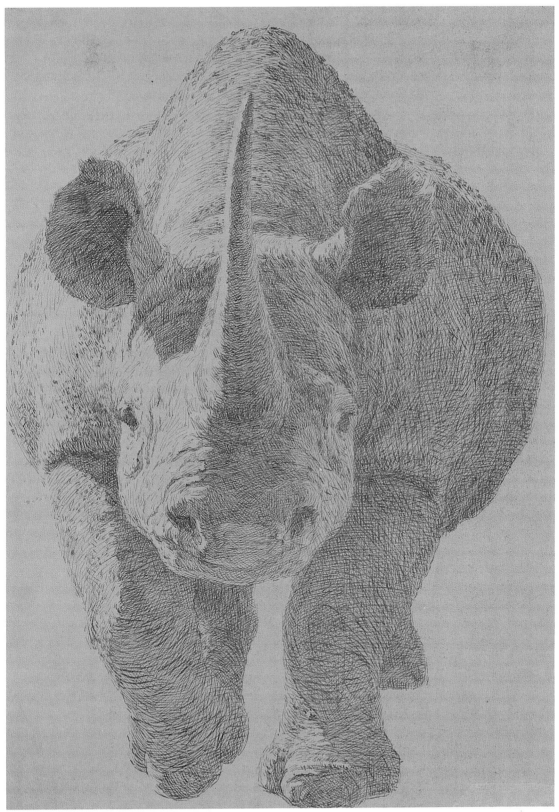

在彩色紙上以單色作畫。順著光影所製造出的凹凸面，
以影線、交叉影線表現形態感，輪廓亦以線條的疏密表
示。

One color of ink was used on colored paper. Hatching and crosshatching
was applied to the shadow areas caused by the contours of the subject to
express the shape. The outline was expressed through the density of the
lines.

線條與上色

一定的製圖筆作出一定粗細的線
A Drafting Pen Produces Lines of Equal Thickness

製圖筆所畫出的線條常具冷漠、強硬之感,但徒手畫的線,卻意外地具有親切的暖意。要畫出一定粗細的線條時,更是方便。

The lines produced by a drafting pen are hard and cold, but if it is used freehand, it can produce an unexpectedly warm effect. It is very useful when an even thickness is required for the outline.

製圖筆:均質的點與線。
Drafting Pen : Produces even lines and dots.

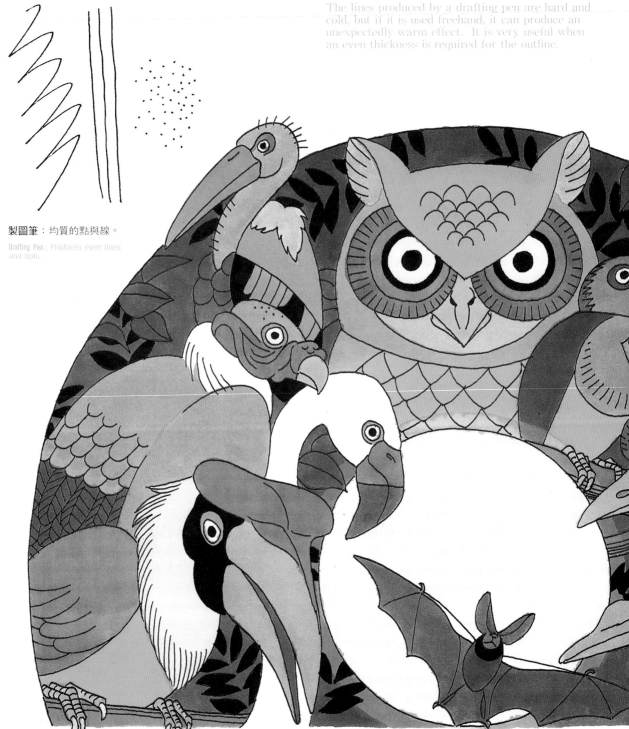

依著鉛筆草圖加上輪廓線後上色。不論有幾種顏色,輪廓線都能使每個形體保持鮮明的輪廓。

The outline was added over a pencil sketch then colored. Even if the color should spread a little, a clear outline allows the shape of the subject to be readily understood.

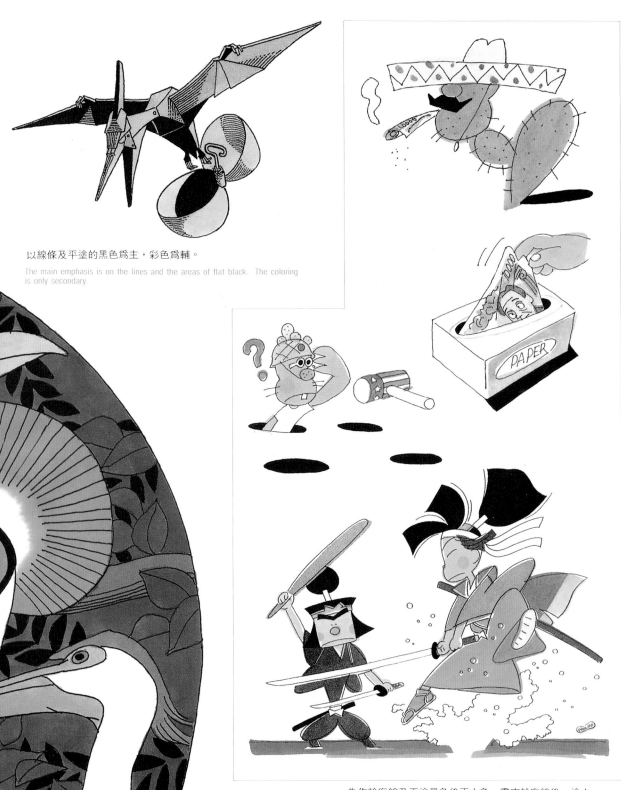

以線條及平塗的黑色爲主，彩色爲輔。

The main emphasis is on the lines and the areas of flat black. The coloring is only secondary.

先作輪廓線及平塗黑色後再上色。畫完輪廓線後，塗上平面性的色彩，表現出一種喜劇性的特性。

The color was added after drawing the outlines and areas of flat black. The color that has been allowed to spread beyond the outline expresses the comical movement of the characters.

彩色墨水的彩色效果
The Effect of Coloring

用飽含顏料的筆,輕敲另一支筆桿,使顏色散落在已乾的圖面上。

Using the handle of a brush as a fulcrum to spatter color over an area that has dried.

在已乾的彩色圖面上,滴上水份。

Spattering water on a colored surface before it has dried.

以水彩筆或鋼筆上色是彩色墨水中較傳統的方法。這裡再介紹一些使畫面更富變化的技法。

Coloring with a pen or brush is an ordinary technique, but here I would like to introduce some more unusual methods.

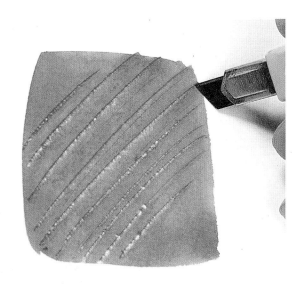

另外滴一些墨水，用力吹口氣，使墨水吹到其他顏色上。

Blow hard on a blot of ink that has been applied to the paper.

以美工刀輕刮已乾的彩色圖面。

Scratching the surface of the color before it has completely dried.

畫紙及發色效果
Paper and its Effect on Brilliance

彩色墨水的發色效果，會受紙張左右。以水彩筆上色時最好選用水彩紙，用肯特紙會産生色斑，最好不用。但若以沾水筆爲主，爲使筆尖滑溜順暢，肯特紙是較好的選擇。粗紙紋的水彩紙，會妨礙製圖筆的流暢性，故選用極細者較恰當。

The type of paper used controls the brilliance of the coloring. When using a brush to apply the ink, watercolor paper is ideal. If Kent paper is used, it will create an unevenness in the color but it is ideal when only a pen is used as it will allow the nib to glide over the surface smoothly. If watercolor paper with a rough texture is used, it might hinder the movement of the nib of a drafting pen so a smooth texture is to be recommended.

發色效果依畫紙而異　Difference of effect on brilliance with paper.

粗紙紋的水彩紙　Rough-textured Watercolor Paper

極細水彩紙　Ultra Fine-textured Watercolor Paper

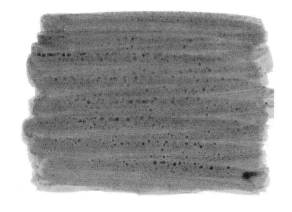

肯特紙　Kent Paper

圖畫紙　Drawing Paper

中紙紋水彩紙：彩色墨水即使以水稀釋，上色後仍有卓越的發色效果，若用有彈性的彈性筆，更能畫出流暢的線條。

Medium-textured Watercolor Paper : The brilliance of the ink is excellent, even when it has been diluted with water. If a flexible nib such as a Kabura is used, the outline may be drawn smoothly.

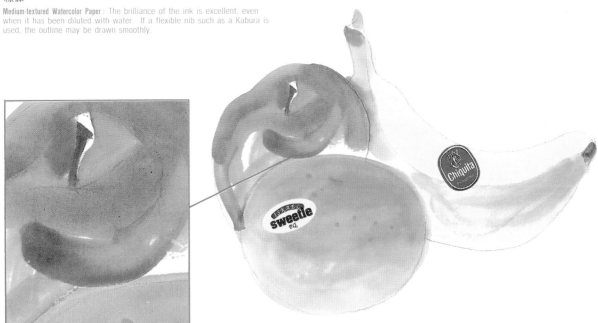

畫仙板：發色效果佳，因具有吸收性，會留下畫筆的筆觸。圖中所貼的貼紙是真實的貼紙。

Chinese Drawing Paper : While the brilliance is excellent, it tends to soak up the ink so the brush strokes remain. The labels were removed from the fruit and fixed to the picture.

展現水彩筆筆觸的增亮劑
Creating Brush Strokes

在彩色墨水中加入壓克力畫用的光澤增亮劑，顏色會
稍微變薄，彩筆的筆觸就像黏著般地殘留在畫面上。
利用這種特質，嘗試創造不同的紋理。

If Acrylic gloss medium is added to color inks, the
colors will become slightly lighter, but it will make
the ink thick enough for the strokes to remain
visible. This characteristic can be used to produce
variety in the surface of the picture.

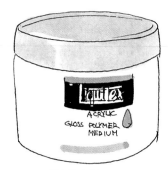

聚合體光澤增亮劑。
Gloss Polymer Medium

彩色墨水加上光澤增亮劑。　　顯出彩筆的筆觸。

The brushstrokes come to life.

Mix with gloss medium.

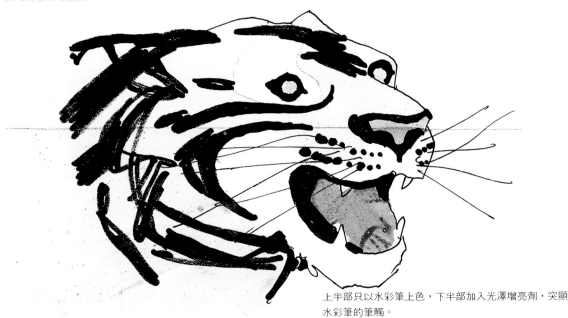

上半部只以水彩筆上色，下半部加入光澤增亮劑，突顯
水彩筆的筆觸。

The top half used only color ink while the bottom half used ink mixed with
gloss medium to bring out the brushstrokes.

背景處為了表現筆觸及運動的動感，在彩色墨水中加入光澤增亮劑再上色。白色部份為白色水彩。

The background uses the brushstrokes to bring out the sporty movement of the subject and so the ink was mixed with gloss medium before application. Watercolor white was also used.

運用白色作畫
Painting with White

1.以黃色為身體的基調，全身塗上黃色。

1.Cover the whole area with the base color of the body which in this case is yellow.

2.加上濃淡的暖色系。

2.Add a warm gradation.

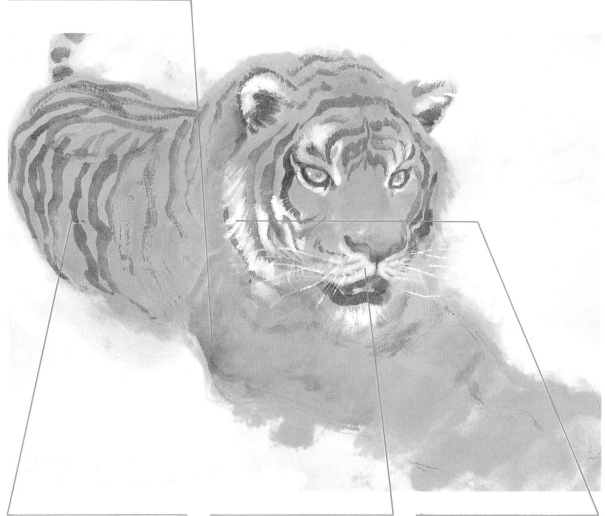

3.等全部的顏色乾後再加上條紋。因其為水溶性墨水，所以會與身體的顏色產生些許融合。

3.Wait until the base colors are quite dry before adding the stripes. The ink is water-based so the stripes will blend slightly with the body color.

4.淡薄的白色看起來有些透明，且與底色混合。

4.Dilute the white so the base color can be seen through it slightly.

5.以乾筆塗上厚厚的白色，表現鬍鬚。

5.Using white on a thickish brush, use the drybrush technique to produce the flow of the fur.

若厚厚的塗上白色水彩，會變成完全不透明的顏色，但如果只淡淡的塗上一層，仍可透出底色。可嘗試利用白色水彩的這種特質，塗在彩色墨水上、描繪動物。此處用的是膠彩。

If white watercolor paint is applied thickly, it is opaque, but a thin coat still allows the lower colors to be seen. Let us use of this characteristic by applying some animals over an area of colored ink. In this picture white gouache was used.

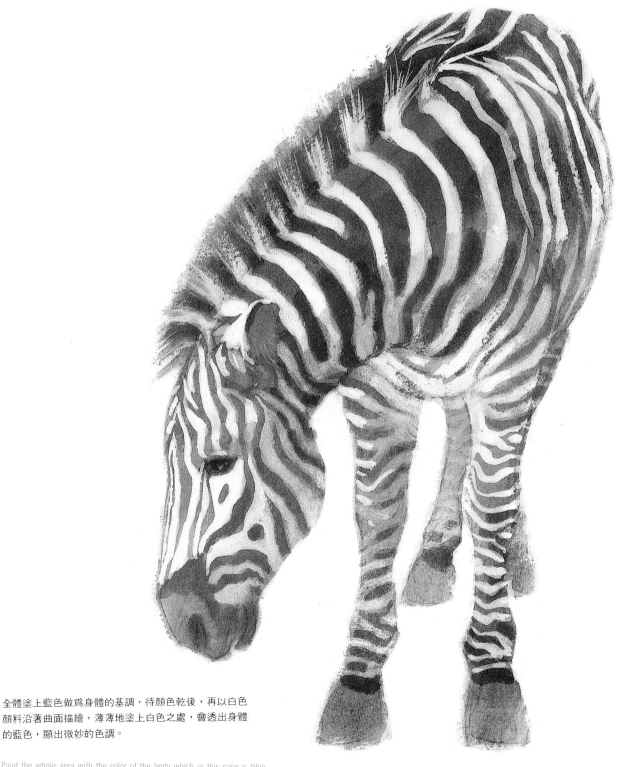

全體塗上藍色做為身體的基調，待顏色乾後，再以白色顏料沿著曲面描繪，薄薄地塗上白色之處，會透出身體的藍色，顯出微妙的色調。

Paint the whole area with the color of the body which in this case is blue. After the base coat has dried, add the stripes, following the contours of the body. In the areas where the diluted white has been added, the base color can still be seen, creating a delicate tone.

彩色麥克筆
Colored Felt-tip Pens

水溶性麥克筆
Water-soluble
Felt-tip Pens

麥克筆的色彩數量豐富，且筆蕊由細
至粗一應俱全。而且不需加墨水，
節省時間使用方便。以水溶性筆線
描後再以含水的水彩筆輕刷，顏色
會暈開，産生水彩風格的效果。

Felt-tip pens come in a vast range
of colors, there are a variety of
sizes of tip from fine to broad and
they save the trouble of applying
ink so they are very useful. If the
water-soluble type are used, the
lines they produce can be gone
over with a wet brush to create a
watercolor effect.

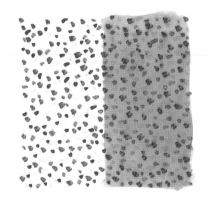
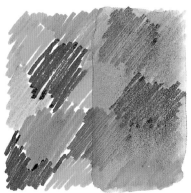
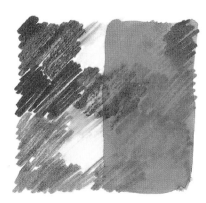

麥克筆畫出的色彩（左）。以含水的水彩筆輕刷後顏色暈開（右）。
Color with a felt-tip pen (left).Go over the color with a wet brush to dissolve the ink (right).

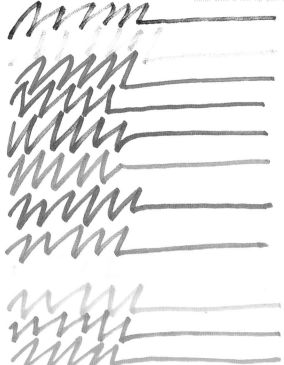

在濕潤的畫紙上打點，顏色即暈開。

If dots are applied to a piece of moistened paper,
they will run.

色彩數量豐富且具有各種粗細不同的筆。

They come in a variety of colors and sizes.

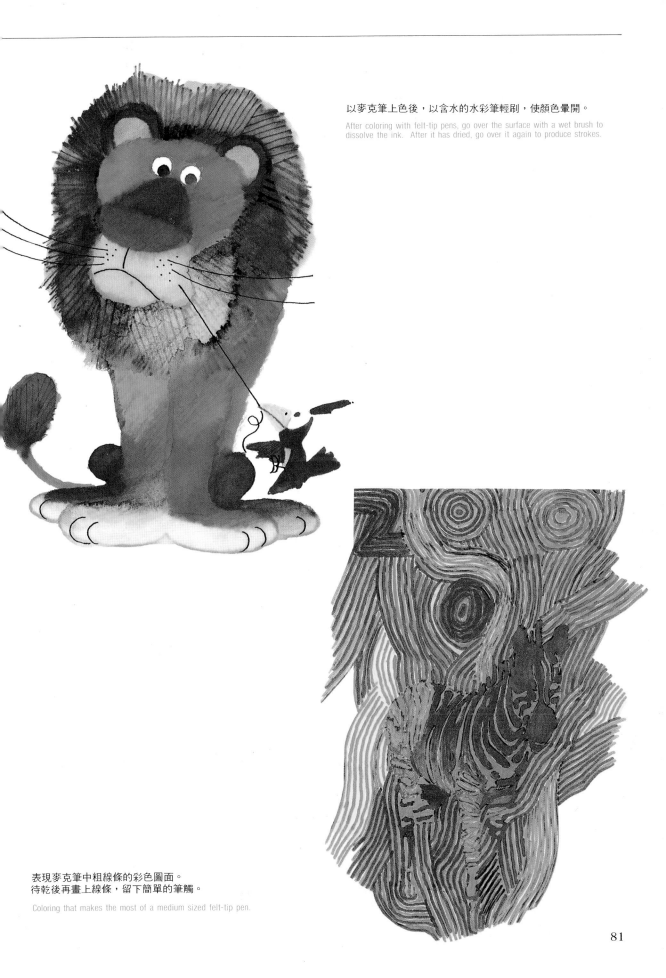

以麥克筆上色後，以含水的水彩筆輕刷，使顏色暈開。

After coloring with felt-tip pens, go over the surface with a wet brush to dissolve the ink. After it has dried, go over it again to produce strokes.

表現麥克筆中粗線條的彩色圖面。
待乾後再畫上線條，留下簡單的筆觸。

Coloring that makes the most of a medium sized felt-tip pen.

以彩色墨水上色後，再以麥克筆加上綠色輪廓線，表現
每個個體的個性，並以鏡中的映像，改變表現方式。

After coloring with ink, a green felt-tip pen was used to go over the outlines of the characters to make them stand out and differ from their reflections in the mirror.

色彩豐富、又可畫出各種粗細線條的彩色麥克筆，可
節省加墨水的時間，方便上色。運用此一優點，可在
彩色墨水上色後加上線條或嘗試以寬幅筆蕊的麥克
筆，一次完成上色。

Felt-tip pens come in a variety of sizes and can
produce both thick and thin lines. They save the
bother of applying ink, making them very useful.
After you have finished coloring in the orthodox
way, use these characteristics to add lines or create
thick strokes.

以黑色的油性麥克筆加上輪廓線後，再以彩色墨水上
色。即使重覆加上彩色墨水，輪廓線依然清晰可見。

The outline was drawn using a black oil-based felt-tip pen then it was
colored with ink. Even when the outline is covered by the ink, it remains
quite clear.

以寬幅筆蕊的麥克筆，一口氣完成上色的彩色圖面。筆
蕊造成的筆觸，在重覆塗上相同的顏色後就會消失，變
成均一色彩的圖面。

A design that was colored using a felt-tip pen with a broad tip. If the same
area is gone over several times, the strokes of the tip will disappear, leaving
an area of flat color.

低彩度色
Lowering the Color Saturation

發色鮮明的彩色墨水，即使混合二種顏色，仍不會降低其彩度。要製造低彩度色時，首先在欲成為低彩度色的顏色中加入黃色，再混合些許的補色即可。

Color inks have brilliant colors and even if two colors are mixed, it will not lower the color saturation. To produce an ink with a low color saturation it is necessary to first add yellow then a small quantity of the complementary color.

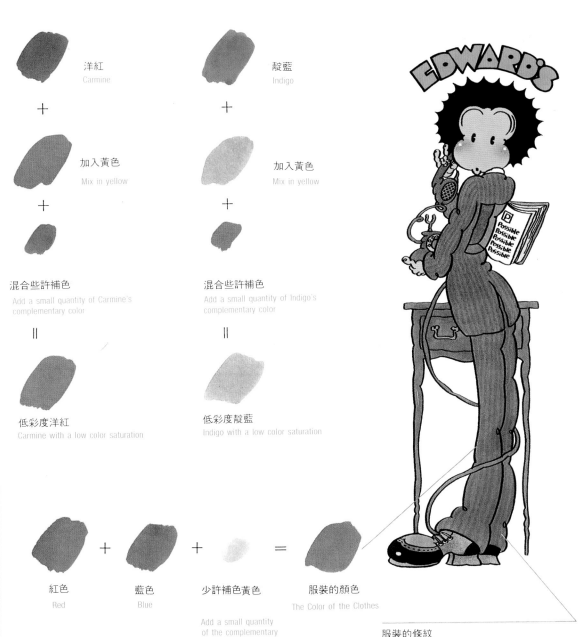

洋紅
Carmine

+

加入黃色
Mix in yellow

+

混合些許補色
Add a small quantity of Carmine's complementary color

=

低彩度洋紅
Carmine with a low color saturation

靛藍
Indigo

+

加入黃色
Mix in yellow

+

混合些許補色
Add a small quantity of Indigo's complementary color

=

低彩度靛藍
Indigo with a low color saturation

紅色
Red

+

藍色
Blue

+

少許補色黃色
Add a small quantity of the complementary color, Yellow

=

服裝的顏色
The Color of the Clothes

服裝的條紋
待紫色乾後，再塗上低彩度的藍色。

The stripes on the clothes
After the purple has dried, build up with a blue of low color saturation

84

第四章

表現與效果

Chapter 4

Expression and Effect

材質感的表現
Expressing Textures

在材質感的表現中首重能掌握、強調製造出光、影的
特徵性部份。在技法上而言，其重點在於有效運用筆
及平塗的效果。

The secret in expressing a feeling of texture is to
exaggerate the areas that display a characteristic
play of light and shade. With regard to technique,
this is controlled by the way in which the lines and
areas of color are applied.

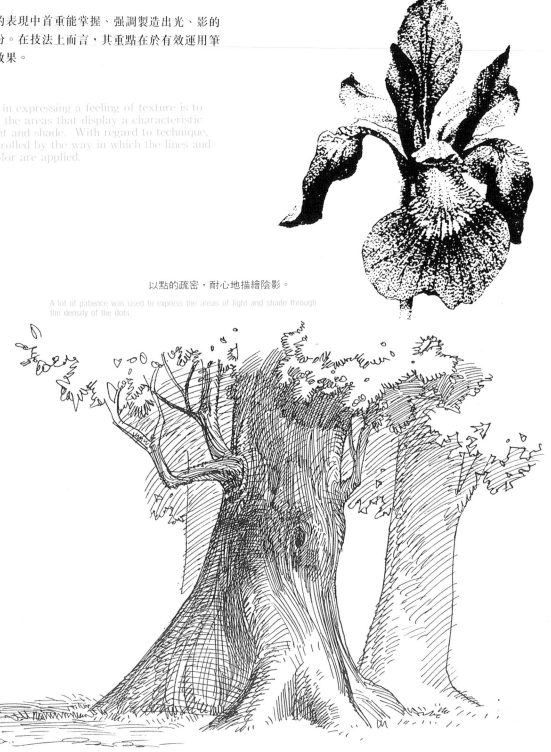

以點的疏密，耐心地描繪陰影。

A lot of patience was used to express the areas of light and shade through
the density of the dots.

強調隨著樹幹的凹凸而改變的線條。

The shading is exaggerated to show the contours of the trunk.

以平塗表現皮革的平滑性,光、影的微妙凹凸則以白色
點描表現。

The smooth leather strap is expressed using flat color with the highlights
added using dots in white. The metallic area is expressed in a light color
with the small areas of shadow added through dots.

掌握隨著玻璃曲面而產生的強光部形態,與平塗處產生對比。

The highlight in the glass is very sharp following the shape of the bottle and
contrasting with the area of flat color.

表示。以沿著曲面的點描、描繪木頭的紋理。
金屬質感是明亮的,少許的陰影部份以點描

The grain of the wood should be shown by dots following the curve of the
bowl.

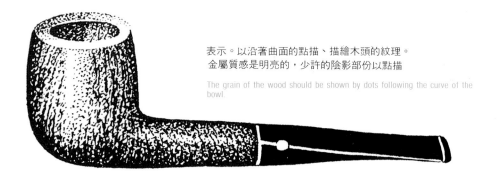

材質感的表現

省略
Abbreviation

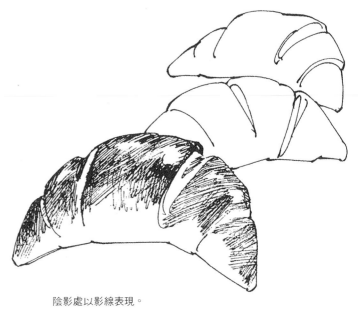

陰影處以影線表現。

The contours of the leaves were expressed through the density of the lines.

以線描描繪籃子的特徵——藤編網眼。

The characteristic weaving of the basketwork has been expressed through lines.

以線條的疏密表現葉片的凹凸。

The shadow was expressed through hatching.

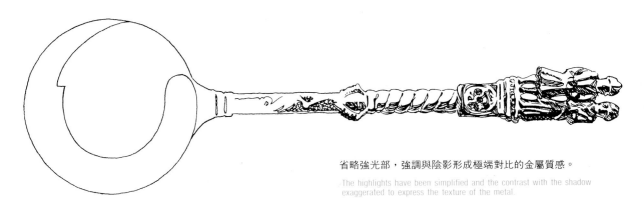

省略強光部，強調與陰影形成極端對比的金屬質感。

The highlights have been simplified and the contrast with the shadow exaggerated to express the texture of the metal.

省略大部份的畫題，僅掌握部份形體的特徵來強調材質感。這也是以筆觸，就是以無調子的線條描繪形體，或以點的疏密來創造調子。

The texture can be stressed by abbreviating the subject and concentrating on the characteristics of certain areas. This can be done either through the strokes of the pen, that is to say, the shape of areas which have no shading, or through the density of dots expressing shading.

部份性的加入沿著花瓣與葉片曲面的影線，其他部份只有線描。

The curve of the leaves and petals have been expressed through hatching in certain areas while the rest is represented through lines.

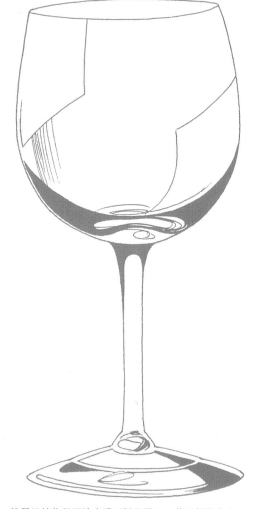

以簡單的線條與平塗表現形體與調子，其他部份省略。

The shape and shading have been expressed though simple lines and flat color. The rest has been abbreviated.

在陰影部加入表現木板平滑感的影線。

Hatching has been used in the areas of shadow to express the flatness of the wood.

黑色的效果
The Effect of Black

與輪廓線的黑色相較之下，平塗的黑色具有產生畫面效果的意義。除了能支配全體的氣氛外，亦有緊縮畫面的功用。

Areas of flat black coloring have a different effect on the overall picture to the black of the outline. Sometimes it sets the mood for the whole picture while on other occasions it serves to draw the picture together.

能使高彩度色看起來具有更高的彩度。

A high color saturation appears even higher.

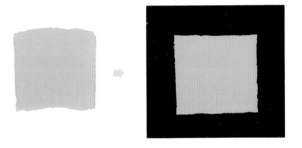

使低明度色看起來變成高明度色。

A low color value is transformed into a high color value.

一與黑色對比，其他的顏色都顯得更明顯。

The contrast of the black causes the other colors to stand out.

以「惡夢」爲題，表現黑色所支配的世界。　　　　"Nightmare." Expressing a world dominated by the color black.

群像的描繪
Drawing a Crowd

描繪人物群像時,在鉛筆草圖階段時,明確的線條是非常重要的。如果輪廓線條清楚,即使色彩有點紊亂,也不會有不自然之感。

When drawing a crowd of people where the figures overlap, it is important to make clear which lines are going to be added in black ink when making the original pencil sketch. As long as the black outlines are drawn clearly, it does not matter if the color spreads a little.

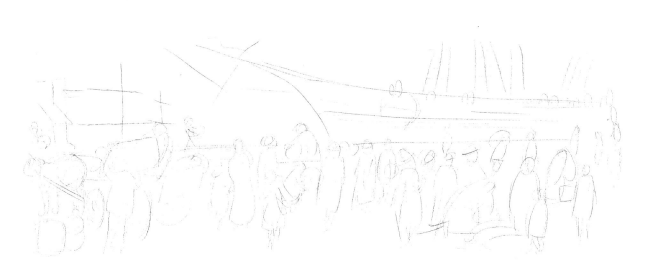

1.以19世紀出港情景為題的鉛筆素描草圖。

1 A rough pencil sketch showing a nineteenth century scene of a ship preparing to leave harbor.

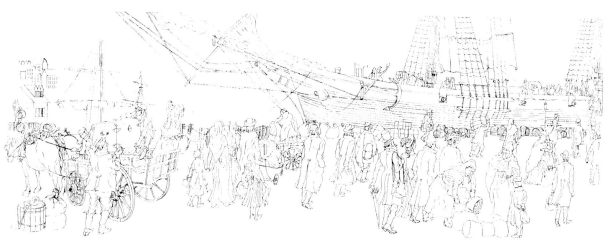

2.依原始印象素描,以鉛筆做綿密線描的畫稿。

2 The original image sketch has been gone over again with a pencil, carefully filling in all the outlines.

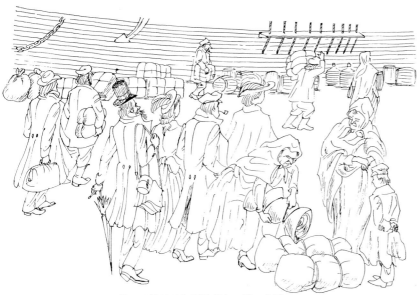

3.畫稿加上部份重點描繪。重疊的群像服裝顏色互異。故要以
0.1mm的製圖筆加上清楚的輪廓。

3.Draw the base picture in sections. The clothes of the people who overlap
will be differentiated through color so draw the outlines clearly using a 0 . 1
m/m. drafting pen.

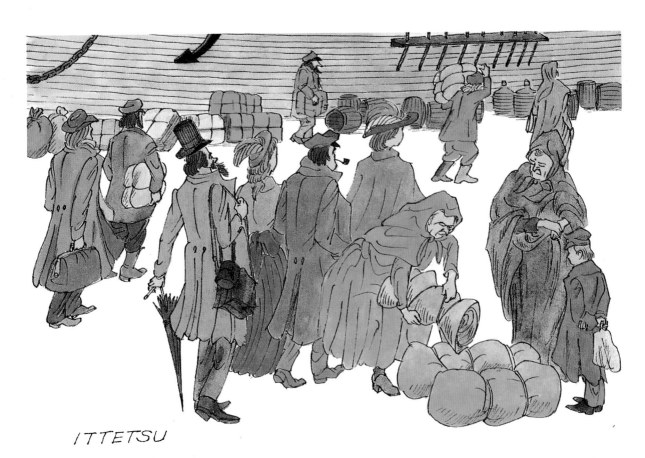

ITTETSU

4.爲表現古典的氣氛,全體色調必需統一,服裝部份塗上色,以
分濃淡。衣摺已以線描表現,不用濃淡,採均一的色彩即可。

4.To give an impression of age, dark tones have been used overall. The
colors of the clothes have been built up in places to create shading. The
folds of the clothes have been drawn with pen lines so it is not necessary to
add tonal variety and a flat coat of color is adequate.

單純化
Simplification

試著以簡潔的線條及顏色,簡單地描繪你對畫題的印象吧!不需拘泥於細部的描寫,重點在於掌握特徵性的形體及色彩。

Try expressing the image you receive from the subject through simple lines and colors. The secret is not to become too involved in details but to concentrate on the characteristic shape or colors.

沾水筆的寫實素描
A realistic pen sketch.

整理筆觸
Neaten the pen strokes.

喜劇性的表現具有特徵性的表情及動作。
The characteristic expression and movement expressed in a comical way.

特徵性的體型與比例的單純化。
A simplification of the characteristic shape and proportions.

以簡潔的線條與顏色表現。
Drawn with simple lines and color.

95

誇大
Exaggeration

部份的誇大也是一種強調畫題特徵的表現方法，誇大或縮小會使整個形體不平衡、不自然，但卻能明確的表現出畫題的特性。

極端誇大臉的某一部份
Enlarging Features of the Face

Another way of stressing the characteristics of the subject is through the exaggeration of various parts. The enlargement or reduction of various parts may make the subject look unnatural and unbalanced, but expresses its character clearly.

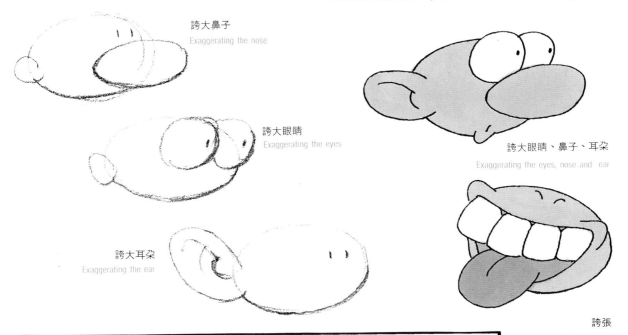

誇大鼻子
Exaggerating the nose

誇大眼睛
Exaggerating the eyes

誇大耳朵
Exaggerating the ear

誇大眼睛、鼻子、耳朵
Exaggerating the eyes, nose and ear

誇張
Exaggerating the mouth

極端誇大臉部
Making the face extremely large

誇大臉部
Exaggerating the Size of the Face

二等身的特性
Make the head the same size as the body.

體型的誇大
Exaggerating the Shape of the Body

誇大肘部及膝蓋的關節
Exaggerate the knees or elbows.

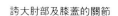

手腳末端縮小
Make the hands or feet excessively small.

手腳末端誇大
Make the hands or feet excessively large

使身體變得又圓又胖
Make the whole body large and round.

加强特色
Making the Subject Move

此誇大及單純化突顯特質後，必需再加上適當的動作
表現。配合可愛、滑稽等感覺的動作也是決定特色的
要素之一。

Once the features of the subject have been
exaggerated or simplified to express its character,
next it must perform suitable actions. The figures
should behave in a cute or amusing way to match
the image they make.

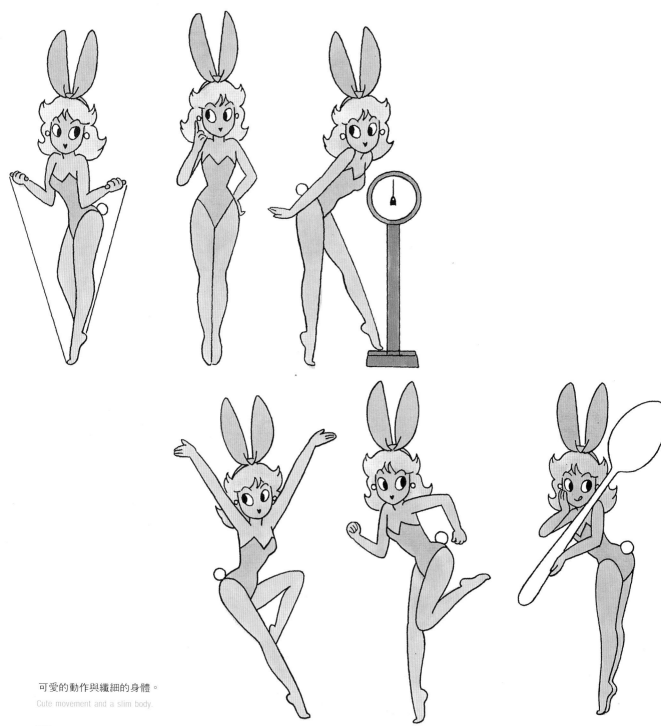

可愛的動作與纖細的身體。

Cute movement and a slim body.

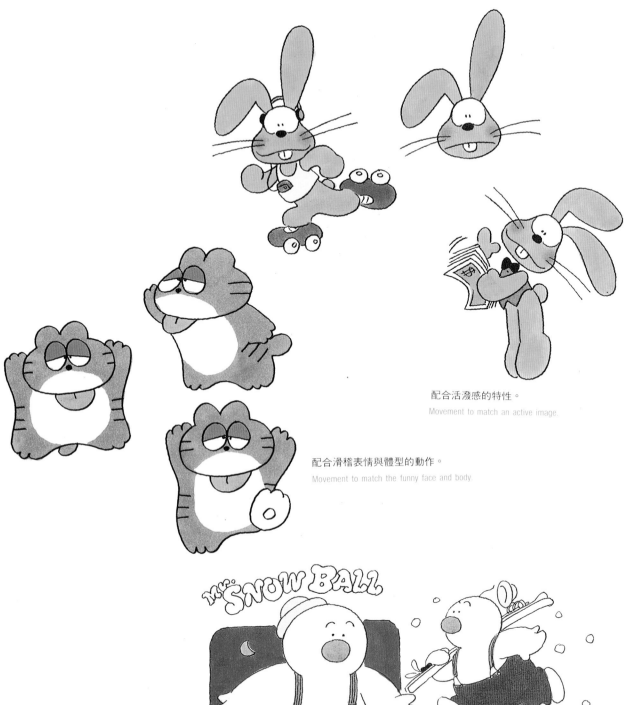

配合活潑感的特性。

Movement to match an active image.

配合滑稽表情與體型的動作。

Movement to match the funny face and body.

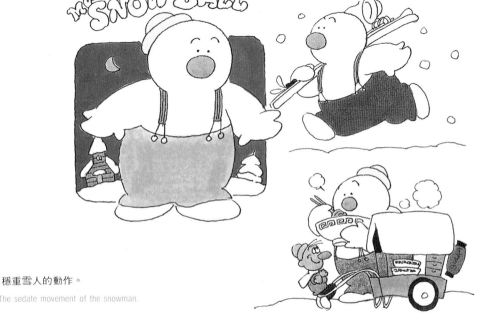

穩重雪人的動作。

The sedate movement of the snowman.

利用影印機
Using a Photocopier

影印機具有放大、縮小、變形、變換顏色等的功能。你可以試著利用影印機製作一張手繪無法表現的作品。

Photocopiers have a variety of functions from enlargement and reduction to distortion or color substitution. A single picture may be altered to produce illustrations that would be impossible to create by hand.

利用色彩變換與變形機能
Utilizing the Color Substitution Function of a Color Photocopier

利用影印機變換顏色的機能，以麥克筆（黑）所描繪的原畫。

A picture drawn with a felt-tip pen (black).

黑色變成藍色，留白變成綠色。

After the black to blue and the white of the paper to green.

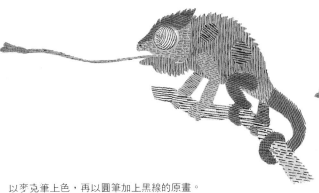

以麥克筆上色，再以圓筆加上黑線的原畫。

A picture drawn using a round nib for the black lines and felt-tip pens for the coloring.

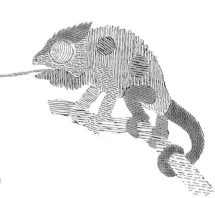

黑線變成紅色。

Alter the black lines to red.

以彩色麥克筆上色的原畫。

A picture that was colored using felt-tip pens.

藍色變成橘紅色。若色彩變換的幅度狹小，則原畫的色斑會分離爲橘紅色與藍色。

Alter the blue to orange. If the color substitution is set to narrow range, the uneven color will separate into orange and blue.

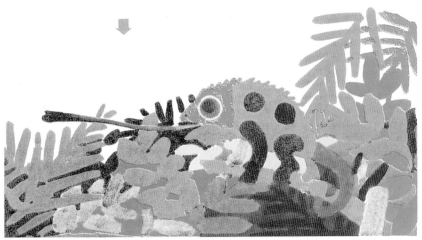

變換幅度大時，藍色就能清楚的轉變爲橘紅色。

If the color substitution range is set to wide, the blue will all change to orange.

利用色彩變換與變形機能
Utilizing the Color Substitution and Distortion Functions

以照片爲原始圖案。
Use a photograph as a base.

在沒有中間色調的影印作品上，塗上彩色墨水
Make a monochrome copy without midtones then color.

以彩色影印作馬賽克處理
Use a color photocopier to create a mosaic effect.

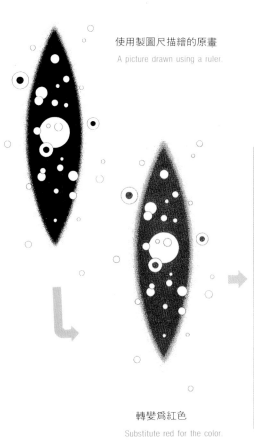

使用製圖尺描繪的原畫

A picture drawn using a ruler.

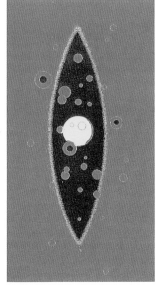

轉變爲紅色

Substitute red for the color.

45度斜體處理。

Revolve through forty-five degrees.

←部份變爲黃色，背景變爲藍色

Change sections to yellow and substitute blue for the background.

以黑色麥克筆描繪的二張原畫，影印在壓克力膜上，分爲藍色及紅色。

Draw two pictures using a black felt-tip pen then use the photocopier to transfer them to transparent film, one in red and one in blue.

二張稍微錯開重疊。

Place on top of each other slightly out of register.

利用影印機

變形與反覆
Distortion and Repetition

使用傳真機、黑白互換
Use a Fax to reverse the black and white.

以製圖筆所描繪的原畫
A picture drawn using a drafting pen.

以傳真機影印，再上彩色墨水
Make a copy of the fax and color with felt-tip pens.

放大影印後再錯開重覆
Alter the degree of enlargement and cause the pictures to overlap.

運用鏡面機能。
Use the mirror function.

改變放大倍率重疊
Use the manual feed to move the original and cause it to overlap

影印時，移動原畫使之變形。
Move the picture while it is being copied to create distortion.

以長體機能印出的變形。
Use the height function to cause distortion.

以平體機能印出的變形。
Use the width function to cause distortion.

製作二張原畫。
Draw two pictures.

複數影印後剪貼。
Make multiple copies and paste them together.

利用影印機

放大縮小

　　鋼筆的點、線爲100％的黑色濃度，很適合做沒有微妙中間調的單色畫影印。以點、線的疏密表現的調子，一經放大會顯現出具有壓迫力的筆觸，縮小後則密度增加，具有細密的表現效果。

Enlargement and Reduction

Lines and dots drawn with a pen have 100% contrast and as they do not contain half-tones they are very suitable for monochrome copies. The shading that is expressed through the density of lines or dots becomes very powerful when it is enlarged and when it is reduced, it becomes much finer and creates an impression of great detail

原始尺寸
Actual Size

縮小50%
50 Percent Reduction

放大150%
150 Percent Enlargement

放大200%
200 Percent Enlargement

利用影印機

製造屏幕調子

嘗試以鋼筆描繪圖案的屏幕調子，畫好一塊圖案後，影印幾份貼合即可。運用鋼筆的線條，貼在背景或作為插圖的暗色調頗能提高效果。

Making a Screen Tone

Try making a Screen Tone using a pattern drawn with a pen. After you have drawn a certain amount, you can make several copies and paste them together. Once it is complete it may be used for the shadow or shading in a pen drawing or for the background to improve an expression.

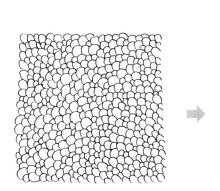

製造圓形圖案。

Make a round pattern.

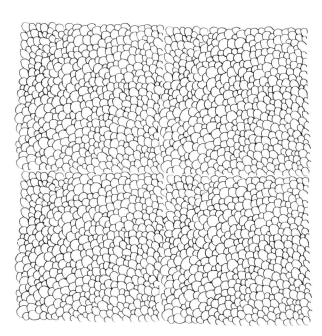

製造四角形圖案。

Make a square pattern.

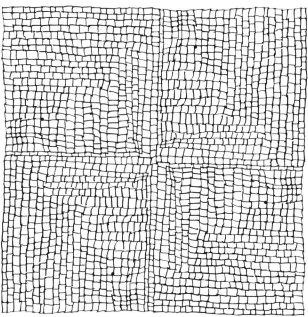

影印四張貼合，成爲連續圖案。

Make four copies of the pattern then paste them together to create a repeated pattern.

徒手畫的直線圖案成爲屏幕調子。

A screen that was created from straight lines which were drawn freehand.

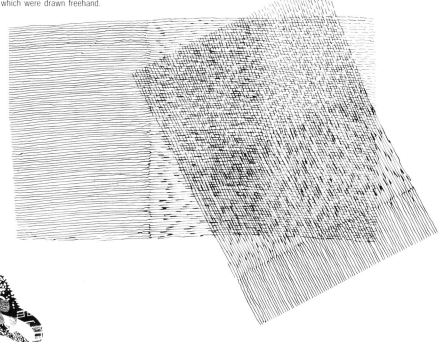

原畫。

Original.

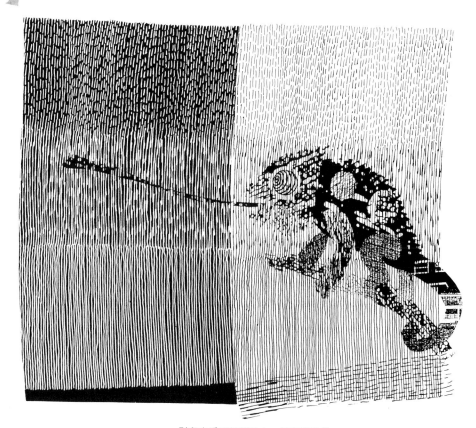

影印在透明的膠片上，與原畫重疊。

Photocopy it onto transparent film and overlap the original.

結語
Afterword

我初學畫時，用的是鋼筆。高中時學製圖用的是製圖筆、沾水筆和墨汁，至今仍然記得5～6色的Hayashi墨水上市，在心中引起的那種激動。這是使我走向較軟性畫風的契機。當時並沒彩色墨水的參考用書，總在不斷的失敗後才學到技巧。

本書可謂集大成的作品，希望能對各位有所助益，最後，感謝成田一徹先生，對本書的遺漏之處加以補正。在此一併致上謝意。

The first pen I ever used was a fountain pen. When I was in senior high school I studied technical illustration using a drawing pen and that was the first time I used a dip pen and ink. I still remember being very excited when Hayashi ink brought out five or six different colored inks and this is what led to my branching out into lighter subjects. In those days there were no books available on using colored ink and I had to teach myself through trial and error. This book represents the sum of the things that I managed to learn and I hope that you will find it useful. Finally, I would like to say thank you to Ittetsu Narita for all his help in producing this book.

トリノまさる

本名：西丸式人1945年生。1972年畢業於東京藝術大學V.D研究所。著有「速寫教室」、「水彩速寫」、「三個模特兒的速寫」、「人像畫法」、「繪畫技法體系」（共著）。及Graphic公司所出版的「彩色鉛筆畫法」、「淡彩素描入門」。

Masaru Torino
Real name : Norito Saimaru
Born in 1945.
In 1972 he completed a postgraduate course in V.D. at the Tokyo National University of Fine Arts and Music.
Previous publications : "Sketching Classroom", "Watercolor Sketching", "Sketching with Three Models", "How to Paint Portraits," "Painting Technique Compendium" (joint work) as well as "Introduction to Colored Pencil Drawings" and "Introduction to Sketching in Watercolors" published by Graphic Sha.

成田一徹

1949年生於神戶市。1976年畢業於大阪經濟大學研究所。善於刻劃酒場情景的剪影畫，以雜誌、書籍爲生活重心、畢生之志，個展12回。

Ittetsu Narita
Born : Kobe 1949
1976 : Completed a postgraduate course at Osaka University of Economics.
He specializes in producing paper cutouts depicting drinking scenes and has produced many works for magazines and books. He has held twelve exhibitions.

名家序文摘要

名家創意識別設計
陳木村先生（中華民國形象研究發展協會理事長）
這是一本用不同手法編排，真正屬於 CI 的書，可以感受到此書能讓讀者用不同的立場，不同的方向去了解 CI 的內涵。

名家創意包裝設計
陳永基先生（陳永基設計工作室負責人）
「消費者第一次是買你的包裝，第二次才是買你的產品」，所以現階段行銷策略、廣告以至包裝設計，就成為決定買賣勝負的關鍵。

名家創意海報設計
柯鴻圖先生（台灣印象海報設計聯誼會會長）
國內出版商願意陸續編輯推廣，闡揚本土化作品，提昇海報的設計地位，個人自是樂觀其成，並予高度肯定。

名家創意

識別 | 包裝 | 海報 設計

北星圖書 新形象

震憾出版

名家・創意系列 ❶

識別設計
——識別設計案例約140件
◎編輯部　編譯　◎定價：1200元

　　此書以不同的手法編排，更是實際、客觀的行動與立場規劃完成的CI書，使初學者、抑或是企業、執行者、設計師等，能以不同的立場，不同的方向去了解CI的內涵；也才有助於CI的導入，更有助於企業產生導入CI的功能。

名家・創意系列 ❷

包裝設計
——包裝案例作品約200件
◎編輯部　編譯　◎定價800元

　　就包裝設計而言，它是產品的代言人，所以成功的包裝設計，在外觀上除了可以吸引消費者引起購買慾望外，還可以立即產生購買的反應；本書中的包裝設計作品都符合了上述的要點，經由長期建立的形象和個性對產品賦予了新的生命。

名家・創意系列 ❸

海報設計
——海報設計作品約200幅
◎編輯部　編譯　◎定價：800元

　　在邁入已開發國家之林，「台灣形象」給外人的感覺卻是不佳的，經由一系列的「台灣形象」海報設計，陸續出現於歐美各諸國中，為台灣掙得了不少的形象，也開啟了台灣海報設計新紀元。全書分理論篇與海報設計精選，包括社會海報、商業海報、公益海報、藝文海報等，實為近年來台灣海報設計發展的代表。

新書推薦

內容精彩・實例豐富

是您值得細細品味、珍藏的好書

商業名片創意設計／PART 1　定價450元

製作工具介紹／名片規格‧紙材介紹／印刷完稿製作

地圖繪製／精緻系列名片／國內外各行各業之創意名片作品欣賞

商業名片創意設計／PART 2　定價450元

CIS的重要／基本設計形式／應用設計發展／探討美的形式／如何設計名片／如何排構成要素

如何改變版面設計／探索名片設計的構圖來源／名片設計欣賞

商業名片創意設計／PART 3　定價450元

色彩與設計／認識色彩／色彩的力量／美麗的配色

名片色彩計劃／國內名片欣賞／國外名片欣賞

新形象出版事業有限公司

北縣中和市中和路322號8F之1／TEL：(02)920-7133／FAX：(02)929-0713／郵撥：0510716-5 陳偉賢

總代理／北星圖書公司

北縣永和市中正路391巷2號8F／TEL：(02)922-9000／FAX：(02)922-9041／郵撥：0544500-7 北星圖書帳戶

門市部：台北縣永和市中正路498號／TEL：(02)928-3810

北星信譽推薦・必備教學好書

日本美術學員的最佳教材

定價／350元　　定價／450元　　定價／450元　　定價／400元　　定價／450元

循序漸進的藝術學園；美術繪畫叢書

定價／450元　　定價／450元　　定價／450元　　定價／450元

最佳工具書

・本書內容有標準大綱編字、基礎素
　描構成、作品參考等三大類；並可
　銜接平面設計課程，是從事美術、
　設計類科學生最佳的工具書。
　編著／葉田園　　定價／350元

精緻手繪POP叢書目錄

新形象出版圖書目錄

郵撥：0510716-5　陳偉賢　　TEL:9207133・9278446　FAX:9290713　　地址：北縣中和市中和路322號8F之1

一、美術設計

代碼	書名	編著者	定價
1-01	新插畫百科(上)	新形象	400
1-02	新插畫百科(下)	新形象	400
1-03	平面海報設計專集	新形象	400
1-05	藝術・設計的平面構成	新形象	380
1-06	世界名家插畫專集	新形象	600
1-07	包裝結構設計		400
1-08	現代商品包裝設計	鄧成連	400
1-09	世界名家兒童插畫專集	新形象	650
1-10	商業美術設計(平面應用篇)	陳孝銘	450
1-11	廣告視覺媒體設計	謝蘭芬	400
1-15	應用美術・設計	新形象	400
1-16	插畫藝術設計	新形象	400
1-18	基礎造形	陳寬祐	400
1-19	產品與工業設計(1)	吳志誠	600
1-20	產品與工業設計(2)	吳志誠	600
1-21	商業電腦繪圖設計	吳志誠	500
1-22	商標造形創作	新形象	350
1-23	插圖彙編(事物篇)	新形象	380
1-24	插圖彙編(交通工具篇)	新形象	380
1-25	插圖彙編(人物篇)	新形象	380

二、POP廣告設計

代碼	書名	編著者	定價
2-01	精緻手繪POP廣告1	簡仁吉等	400
2-02	精緻手繪POP2	簡仁吉	400
2-03	精緻手繪POP字體3	簡仁吉	400
2-04	精緻手繪POP海報4	簡仁吉	400
2-05	精緻手繪POP展示5	簡仁吉	400
2-06	精緻手繪POP應用6	簡仁吉	400
2-07	精緻手繪POP變體字7	簡志哲等	400
2-08	精緻創意POP字體8	張麗琦等	400
2-09	精緻創意POP插圖9	吳銘書等	400
2-10	精緻手繪POP畫典10	葉辰智等	400
2-11	精緻手繪POP個性字11	張麗琦等	400
2-12	精緻手繪POP校園篇12	林東海等	400
2-16	手繪POP的理論與實務	劉中興等	400

三、圖學、美術史

代碼	書名	編著者	定價
4-01	綜合圖學	王鍊登	250
4-02	製圖與議圖	李寬和	280
4-03	簡新透視圖學	廖有燦	300
4-04	基本透視實務技法	山城義彥	300
4-05	世界名家透視圖全集	新形象	600
4-06	西洋美術史(彩色版)	新形象	300
4-07	名家的藝術思想	新形象	400

四、色彩配色

代碼	書名	編著者	定價
5-01	色彩計劃	賴一輝	350
5-02	色彩與配色(附原版色票)	新形象	750
5-03	色彩與配色(彩色普級版)	新形象	300

五、室內設計

代碼	書名	編著者	定價
3-01	室內設計用語彙編	周重彥	200
3-02	商店設計	郭敏俊	480
3-03	名家室內設計作品專集	新形象	600
3-04	室內設計製圖實務與圖例(精)	彭維冠	650
3-05	室內設計製圖	宋玉真	400
3-06	室內設計基本製圖	陳德貴	350
3-07	美國最新室內透視圖表現法1	羅啓敏	500
3-13	精緻室內設計	新形象	800
3-14	室內設計製圖實務(平)	彭維冠	450
3-15	商店透視-麥克筆技法	小椋勇記夫	500
3-16	室內外空間透視表現法	許正孝	480
3-17	現代室內設計全集	新形象	400
3-18	室內設計配色手册	新形象	350
3-19	商店與餐廳室內透視	新形象	600
3-20	櫥窗設計與空間處理	新形象	1200
8-21	休閒俱樂部・酒吧與舞台設計	新形象	1200
3-22	室內空間設計	新形象	500
3-23	櫥窗設計與空間處理(平)	新形象	450
3-24	博物館&休閒公園展示設計	新形象	800
3-25	個性化室內設計精華	新形象	500
3-26	室內設計&空間運用	新形象	1000
3-27	萬國博覽會&展示會	新形象	1200
3-28	中西傢俱的淵源和探討	謝蘭芬	300

六、SP行銷・企業識別設計

代碼	書名	編著者	定價
6-01	企業識別設計	東海・麗琦	450
6-02	商業名片設計(一)	林東海等	450
6-03	商業名片設計(二)	張麗琦等	450
6-04	名家創意系列①識別設計	新形象	1200

七、造園景觀

代碼	書名	編著者	定價
7-01	造園景觀設計	新形象	1200
7-02	現代都市街道景觀設計	新形象	1200
7-03	都市水景設計之要素與概念	新形象	1200
7-04	都市造景設計原理及整體概念	新形象	1200
7-05	最新歐洲建築設計	石金城	1500

八、廣告設計、企劃

代碼	書名	編著者	定價
9-02	CI與展示	吳江山	400
9-04	商標與CI	新形象	400
9-05	CI視覺設計(信封名片設計)	李天來	400
9-06	CI視覺設計(DM廣告型錄)(1)	李天來	450
9-07	CI視覺設計(包裝點線面)(1)	李天來	450
9-08	CI視覺設計(DM廣告型錄)(2)	李天來	450
9-09	CI視覺設計(企業名片吊卡廣告)	李天來	450
9-10	CI視覺設計(月曆PR設計)	李天來	450
9-11	美工設計完稿技法	新形象	450
9-12	商業廣告印刷設計	陳穎彬	450
9-13	包裝設計點線面	新形象	450
9-14	平面廣告設計與編排	新形象	450
9-15	CI戰略實務	陳木村	
9-16	被遺忘的心形象	陳木村	150
9-17	CI經營實務	陳木村	280
9-18	綜藝形象100序	陳木村	

九、繪畫技法

代碼	書名	編著者	定價
8-01	基礎石膏素描	陳嘉仁	380
8-02	石膏素描技法專集	新形象	450
8-03	繪畫思想與造型理論	朴先圭	350
8-04	魏斯水彩畫專集	新形象	650
8-05	水彩靜物圖解	林振洋	380
8-06	油彩畫技法1	新形象	450
8-07	人物靜物的畫法2	新形象	450
8-08	風景表現技法3	新形象	450
8-09	石膏素描表現技法4	新形象	450
8-10	水彩・粉彩表現技法5	新形象	450
8-11	描繪技法6	葉田園	350
8-12	粉彩表現技法7	新形象	400
8-13	繪畫表現技法8	新形象	500
8-14	色鉛筆描繪技法9	新形象	400
8-15	油畫配色精要10	新形象	400
8-16	鉛筆技法11	新形象	350
8-17	基礎油畫12	新形象	450
8-18	世界名家水彩(1)	新形象	650
8-19	世界水彩作品專集(2)	新形象	650
8-20	名家水彩作品專集(3)	新形象	650
8-21	世界名家水彩作品專集(4)	新形象	650
8-22	世界名家水彩作品專集(5)	新形象	650
8-23	壓克力畫技法	楊恩生	400
8-24	不透明水彩技法	楊恩生	400
8-25	新素描技法解說	新形象	350
8-26	畫鳥・話鳥	新形象	450
8-27	噴畫技法	新形象	550
8-28	藝用解剖學	新形象	350
8-30	彩色墨水畫技法	劉興治	400
8-31	中國畫技法	陳永浩	450
8-32	千嬌百態	新形象	450
8-33	世界名家油畫專集	新形象	650
8-34	插畫技法	劉芷芸等	450
8-35	實用繪畫範本	新形象	400
8-36	粉彩技法	新形象	400
8-37	油畫基礎畫	新形象	400

十、建築、房地產

代碼	書名	編著者	定價
10-06	美國房地產買賣投資	解時村	220
10-16	建築設計的表現	新形象	500
10-20	寫實建築表現技法	濱脇普作	400

十一、工藝

代碼	書名	編著者	定價
11-01	工藝概論	王銘顯	240
11-02	籐編工藝	龐玉華	240
11-03	皮雕技法的基礎與應用	蘇雅汾	450
11-04	皮雕藝術技法	新形象	400
11-05	工藝鑑賞	鐘義明	480
11-06	小石頭的動物世界	新形象	350
11-07	陶藝娃娃	新形象	280
11-08	木彫技法	新形象	300

十二、幼敎叢書

代碼	書名	編著者	定價
12-02	最新兒童繪畫指導	陳穎彬	400
12-03	童話圖案集	新形象	350
12-04	敎室環境設計	新形象	350
12-05	敎具製作與應用	新形象	350

十三、攝影

代碼	書名	編著者	定價
13-01	世界名家攝影專集(1)	新形象	650
13-02	繪之影	曾崇詠	420
13-03	世界自然花卉	新形象	400

十四、字體設計

代碼	書名	編著者	定價
14-01	阿拉伯數字設計專集	新形象	200
14-02	中國文字造形設計	新形象	250
14-03	英文字體造形設計	陳穎彬	350

十五、服裝設計

代碼	書名	編著者	定價
15-01	蕭本龍服裝畫(1)	蕭本龍	400
15-02	蕭本龍服裝畫(2)	蕭本龍	500
15-03	蕭本龍服裝畫(3)	蕭本龍	500
15-04	世界傑出服裝畫家作品展	蕭本龍	400
15-05	名家服裝畫專集1	新形象	650
15-06	名家服裝畫專集2	新形象	650
15-07	基礎服裝畫	蔣愛華	350

十六、中國美術

代碼	書名	編著者	定價
16-01	中國名畫珍藏本		1000
16-02	沒落的行業一木刻專輯	楊國斌	400
16-03	大陸美術學院素描選	凡 谷	350
16-04	大陸版畫新作選	新形象	350
16-05	陳永浩彩墨畫集	陳永浩	650

十七、其他

代碼	書名	定價
X0001	印刷設計圖案(人物篇)	380
X0002	印刷設計圖案(動物篇)	380
X0003	圖案設計(花木篇)	350
X0004	佐滕邦雄(動物描繪設計)	450
X0005	精細插畫設計	550
X0006	透明水彩表現技法	450
X0007	建築空間與景觀透視表現	500
X0008	最新噴畫技法	500
X0009	精緻手繪POP插圖(1)	300
X0010	精緻手繪POP插圖(2)	250
X0011	精細動物插畫設計	450
X0012	海報編輯設計	450
X0013	創意海報設計	450
X0014	實用海報設計	450
X0015	裝飾花邊圖案集成	380
X0016	實用聖誕圖案集成	380

沾水筆、彩色墨水技法

定價：400元

出　版　者：新形象出版事業有限公司
負　責　人：陳偉賢
地　　　址：台北縣中和市中和路322號8F之1
門　　　市：北星圖書事業股份有限公司
　　　　　　永和市中正路498號
電　　　話：9229000(代表)　　ＦＡＸ：9229041

原　　　著：Masaru Tovino
　　　　　　Ittetsu Narita
編　譯　者：新形象出版公司編輯部
發　行　人：顏義勇
總　策　劃：陳偉昭
文字編輯：高妙君

總　代　理：北星圖書事業股份有限公司
地　　　址：台北縣永和市中正路462號5F
電　　　話：9229000(代表)　　ＦＡＸ：9229041
郵　　　撥：0544500-7北星圖書帳戶
印　刷　所：皇甫彩藝印刷股份有限公司

行政院新聞局出版事業登記證／局版台業字第3928號
經濟部公司執／76建三辛字第214743號

1997年1月　　第一版第一刷

國家圖書館出版品預行編目資料

沾水筆・彩色墨水技法：Introduction to
drawing with pen and color ink／Masaru
Tovino, Ittetsu Narita原著；新形象編輯部
編譯．— 第一版．— 臺北縣中和市：新形象
，1996[民85]
　　面；　　公分
ISBN 957-9679-04-5(精裝)

1.鋼筆畫

948.3　　　　　　　　　　　　　　85012955